SHELTER
puppies

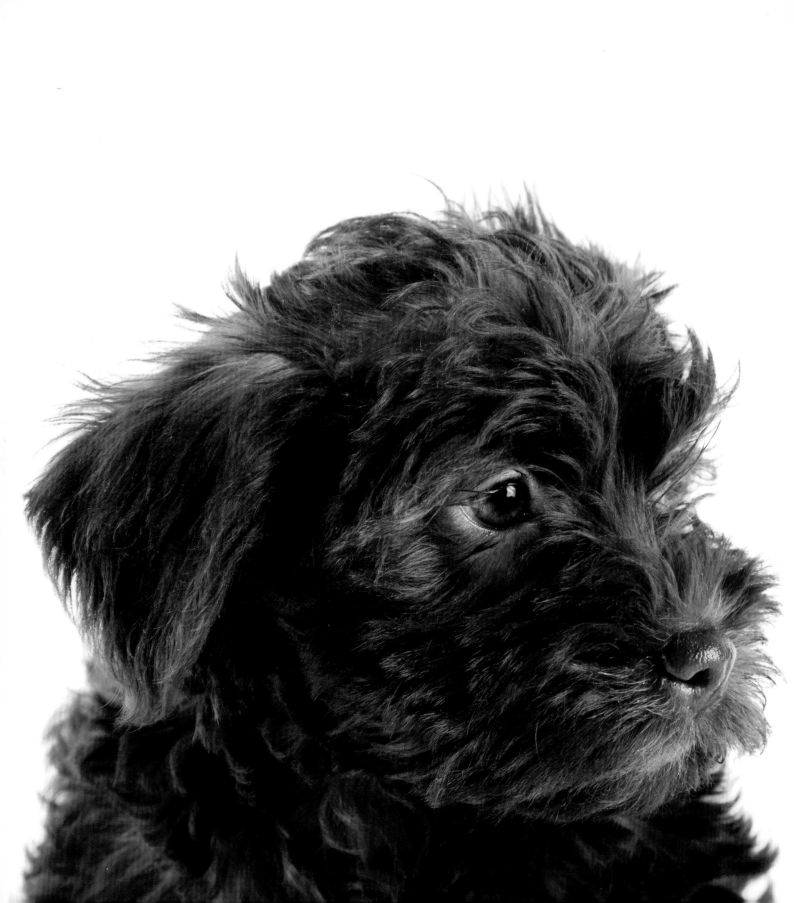

SHELTER
puppies

michael kloth

MERRELL
LONDON · NEW YORK

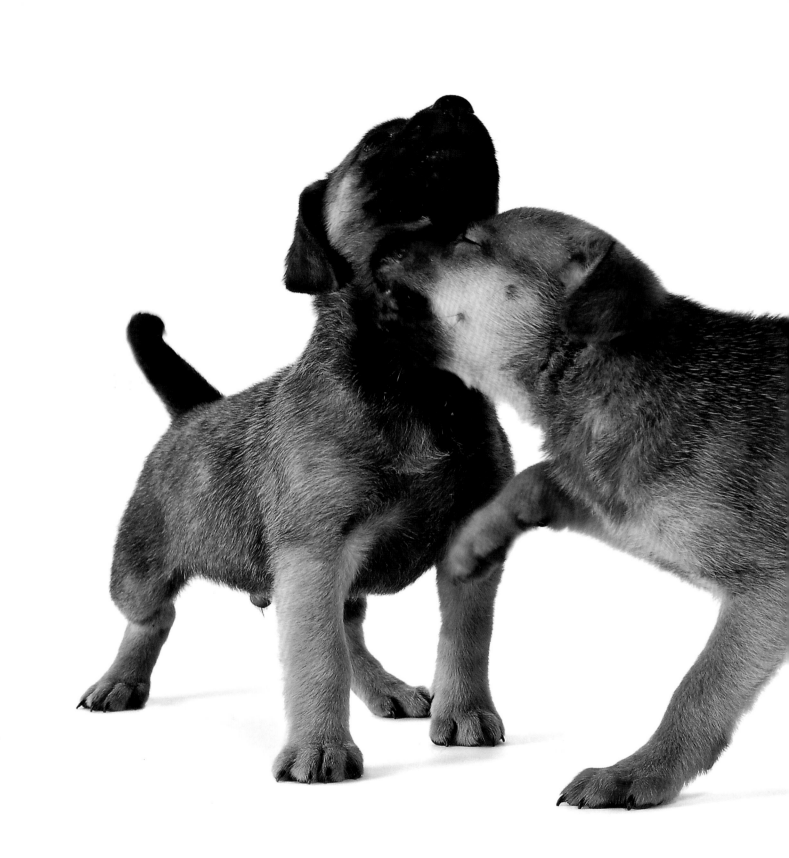

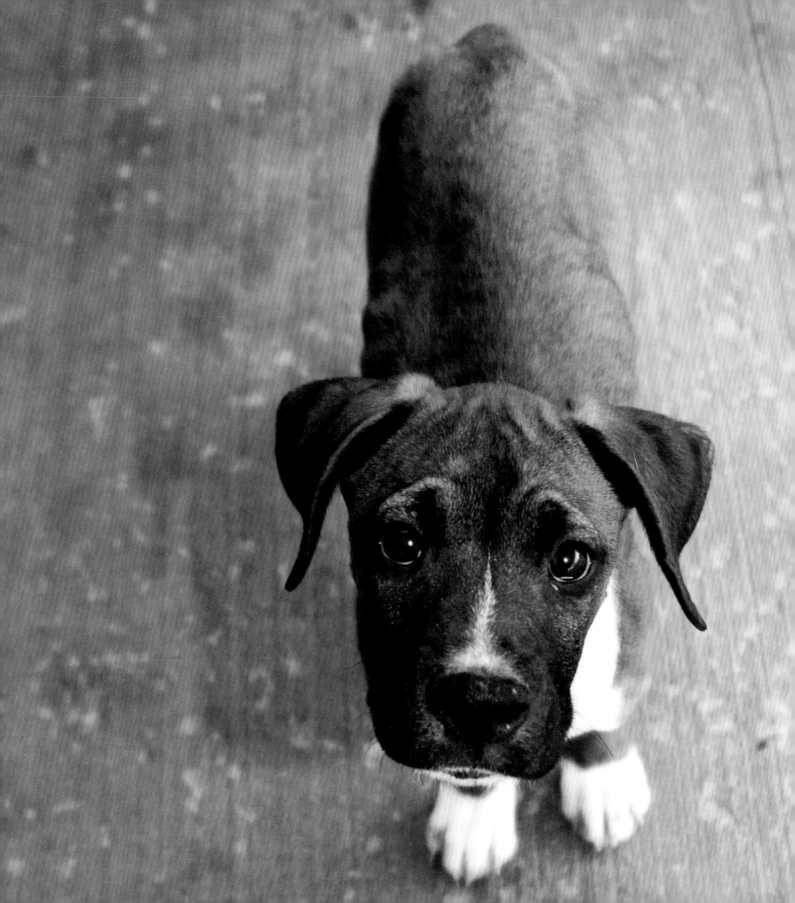

Introduction

I've had dogs most of my life, but my first puppy was named Nicky. I can still remember the night my parents brought her home. She was an early Christmas gift and arrived on St Nick's day.[1] (My sister and I were admittedly not very creative in naming her.) Nicky was a small dog and even as an adult weighed in at maybe 12 or 13 pounds, but as a puppy she was sheer joy in a tiny package. From that very first night, she captured my heart, and I remember vividly wanting to skip school the next day. Nicky wasn't a shelter puppy, but she was a mutt through and through. She introduced me to the joys of the mixed-breed dog, and every dog I've lived with since then has been adopted from a humane society, SPCA, or animal shelter. Even though Nicky lived to old age, my time with her was far too short, and all these years later I still cherish those memories and the few photographs I have.

The decision to bring a puppy into your home should be all about the excitement and possibility of a lifetime of friendship. This book is meant to celebrate that excitement while also promoting adoption and responsible animal stewardship. It is my sincere hope that everyone who reads this book and looks at these portraits will consider adoption first when it's time to bring a new animal home. And of course, once you bring your new puppy home, please, please spay or neuter your pet.

Puppies are cute. Puppies are playful. Puppies have puppy breath and if you like that sort of thing, then that's also a positive. But puppies are a lot of work. If you put in the time for training and socializing your new pup, you will have a dear friend and lifelong companion. Those who don't invest time in their puppy's upbringing may end up dealing with a difficult dog for life; worse, that puppy may grow into a dog that gets sent to an animal shelter, facing a very uncertain fate. I am a firm believer in animal adoption, and I most definitely recommend that anyone interested in bringing a puppy into their home first visit their local humane society, animal shelter, or rescue group before making any decisions. In fact, I'd encourage visiting several times. Taking on the responsibility for a new life should not be approached casually, but with the right preparation and commitment, you and your new puppy will create a lifetime of happy memories together.

There are valid reasons to buy a puppy from a breeder instead of adopting from a shelter, but this book is not about those reasons. I hope that I can encourage everyone who reads this book and looks at these pictures to

I photographed this boxer mix puppy shortly after I began volunteering at humane societies. She was one of my earliest success stories and quickly found her "forever home."

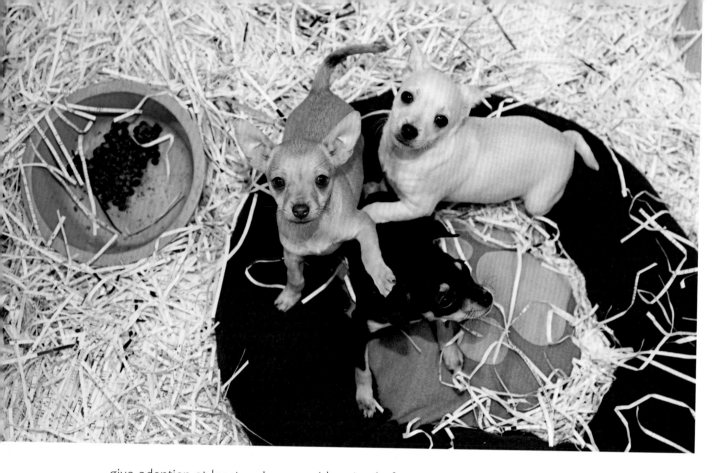

give adoption at least serious consideration before going to meet with a breeder, because—let's face it—it's difficult to say "no" when confronted with an adorable bundle of fur pulling gently at your shoe (and heart) strings. My hope is that if you visit a shelter first, you'll make that connection with one of their puppies waiting patiently for a "forever home."

Approximately 25 percent of dogs brought to animal shelters are purebred.[2] Although there are no related studies showing the number of purebred puppies in shelters, my experience is that they make up a relatively small percentage of all puppies available for adoption. This isn't really much of a surprise, in light of the fact that purebred puppies and even "designer mix" puppies can sell for hundreds or even thousands of dollars. Still, even if you have your heart set on a particular breed or mix, it's worth contacting your local rescue to ask if those puppies are currently available.

Chihuahua puppies in their pen prior to their portrait session. I do not photograph puppies in their pens for their adoption pages because I believe it emphasizes their situation over their individual personalities.

This is a book about puppies, but I'd be remiss if I didn't first make the point that adopting a puppy isn't the right choice for everyone looking to bring a dog into their home. Puppies require a fair bit of training, veterinary care, and exercise in order to grow into healthy and well-adjusted dogs. Busy

households or homes with small children might be better off adopting an adult dog that has already been house-trained, and might even have received some basic obedience training. With good care and a bit of luck, bringing a puppy into your home could be a commitment of fifteen years or more, so it makes sense that the decision should be made only after careful consideration. As cute and adorable as puppies are, that period of their life is relatively short and is full of challenges; the sacrifice of missing that stage of a dog's life by instead adopting an adult dog may be the right choice for potential adopters. As someone who has adopted both puppies and adult dogs, I can say with some certainty that the joys and challenges of each are equally rewarding. Maybe you will even find yourself in the fortunate position of adopting a puppy and an adult together, and if that is the case, you can take comfort from knowing that while assuming responsibility for two dogs is obviously more work than having just one dog, it is likely not twice the work.

Two Labrador mix puppies take a break from playing to pose for my camera.

For those of you intent on adopting a shelter puppy, congratulations! Celebrate that time of rapid growth and cuteness. Take lots of pictures (or hire someone to do that for you), and take even more trips outside with your new best friend so that he can quickly get the hang of house-training. Take

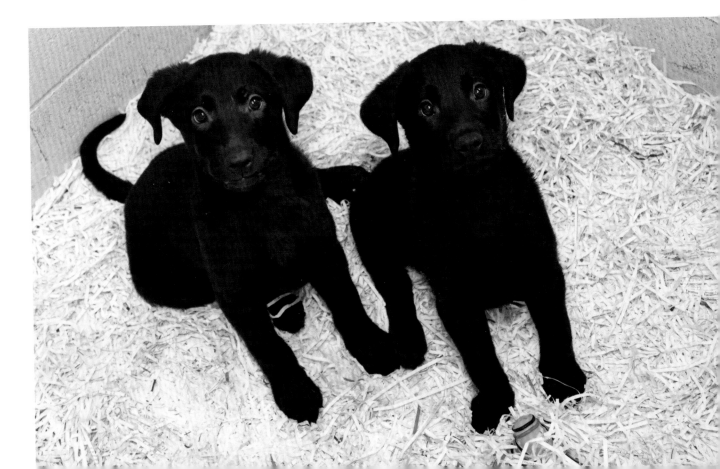

pleasure in helping your puppy explore and discover his new world. Puppyhood passes quickly, so enjoy every moment! Please consider spaying or neutering your new charge, because our shelters still are faced with the difficult task of euthanizing millions of animals every year. Also, do consider microchipping your new puppy. Only 30 percent of lost dogs brought to animal shelters are ever reunited with their families.[3] Giving your dog a microchip and keeping your contact information up to date is the most reliable way to ensure that a lost-animal scare results in a happy ending.

Back in the 1970s and early 1980s, when my family adopted Nicky, dogs and cats at animal shelters faced very poor chances for adoption: nearly 20 million animals were euthanized each year.[4] If you've read Traer Scott's book *Shelter Dogs* or my *Shelter Cats*, you know that today between six and eight million cats and dogs are brought to American animal shelters each year and that only half of them ever find a home.[5] That's a huge improvement over the last several decades, but, of course, we still have a long way to go before we can effectively end the euthanasia of adoptable animals. Those numbers represent all cats and dogs, not just puppies and kittens. The happy fact is that most healthy puppies (and kittens) today do get adopted, but unfortunately that doesn't always ensure a perfect ending. Yet with a bit of time and foresight, the decision to adopt a puppy from a humane society or an animal shelter can lead to a lifetime of love.

I currently volunteer my professional photographic skills to local animal shelters and rescue centers nearly every week. I've met and photographed thousands of animals since my first day volunteering at the Woodford Humane Society, in Versailles, Kentucky, on Valentine's Day, 2006. I've been fortunate to work with organizations that have a much higher adoption rate than the average in the United States, but I have still been devastated to learn on countless occasions that animals I've come to know have been euthanized. Puppies typically have higher adoption rates than the rest of the animals; they often find a home after only a few days or weeks. Sadly, some of these puppies are returned to the shelter after a short time because their adopted family did not fully accept the commitment involved in raising a dog. Frequently the puppy is returned during those awkward "teenage" months—six months to a year or so—when puppies are teething, challenging boundaries, and growing like crazy.

This problem may be compounded by the fact that puppies are often chosen on the basis of how they look when they are a few weeks old, and with no consideration given to what their characteristics might be when they are a mature adult. While shelter staff sometimes resort to making a "best guess" at breed type or breed mixes, those determinations can be helpful when it

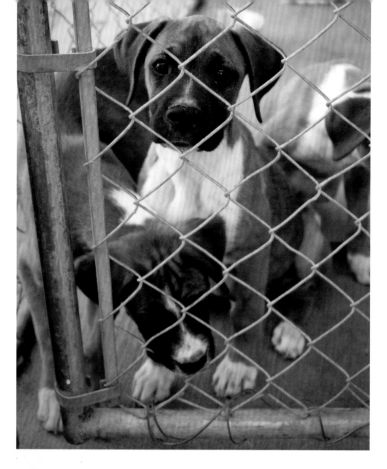

comes to predicting a dog's major personality type. Choosing a puppy that will fit in with your lifestyle will make the transition easier for both of you. Once you've adopted your puppy and shared your first weeks and months together, you can help your dog deal with the difficult stage of adolescence with plenty of exercise, training, and patience. This will not only help your puppy develop into a healthy adult, but will also serve to strengthen your dog's bond with you and your family.

As you might be able to guess from looking through these portraits and reading the biographies, *Shelter Puppies* was a joy to create. After all, what could be more fun than going to work in the morning knowing that the day's agenda involves playing with incredibly cute, soft, and lively puppies? I'm delighted to share a bit of this joy with you through my images featured in *Shelter Puppies*. It's worth mentioning that these portraits were not created with a book in mind. In working with adoptable animals, my primary goal is always the same: to showcase the animal's personality in such a way as to entice potential adopters to visit the shelter.

Boxer mix puppies in an outdoor run. I believe that photographing puppies in cages or behind chain-link fences sets the wrong tone for adoption profiles by evoking a sense of sadness or pity. Removing these external cues and photographing the pups against an uncluttered background encourages potential adopters to connect with the puppies before they even visit the shelter.

I believe that many rescue centers miss the mark when they photograph their charges for their adoption profiles. Photographs that are blurry or poorly exposed, or that depict frightened or angry animals, do very little to help market these animals to potential adopters, and might even harm their chance of ever finding a home. Anyone who has ever seen puppies wrestle knows that they can look downright vicious at times; photographs of puppies at play may inadvertently project a negative impression if not timed carefully or shown in context. My goal for every session is to capture the essence of the puppy—from the playful puppy strut to the shy and timid, and everything in between—so that when

potential adopters see the portraits and profiles, they get a true sense of each puppy's personality.

I hope that as you look through this book and learn a bit about the puppies featured, I might persuade you to consider adoption as your first option when you are ready to bring a new pet into your life. There are so many beautiful, sweet, loving puppies in animal shelters waiting for their forever homes that I honestly believe there is a good match for anyone looking for a dog. Please give them a chance by going to meet them at your local humane society, animal shelter, rescue center, or SPCA.

Two hound mix puppies sleep in the Woodford Humane Society's puppy room.

Notes

1 Saint Nicholas day is celebrated on December 6. See http://www.stnicholascenter.org/pages/who-is-st-nicholas (accessed 2/15/11).

2 http://www.humanesociety.org/issues/pet_overpopulation/facts/overpopulation_estimates.html (accessed 3/14/11).

3 *Ibid.*

4 http://www.humanesociety.org/animal_community/resources/qa/common_questions_on_shelters.html (accessed 3/14/11).

5 Traer Scott, *Shelter Dogs*, London (Merrell) 2006. Michael Kloth, *Shelter Cats*, London (Merrell) 2010.

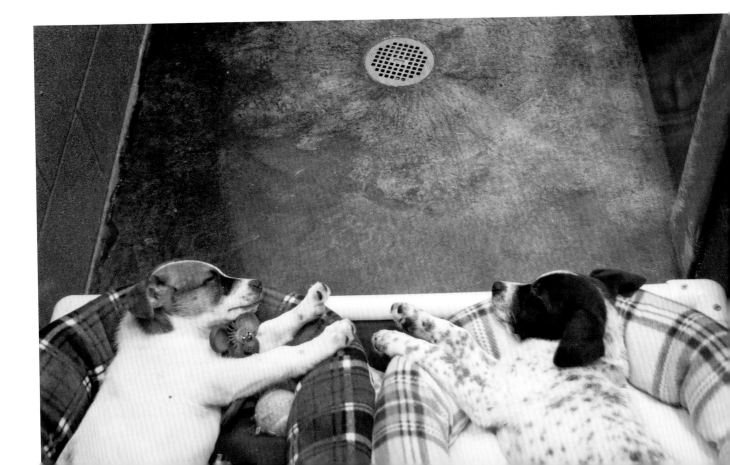

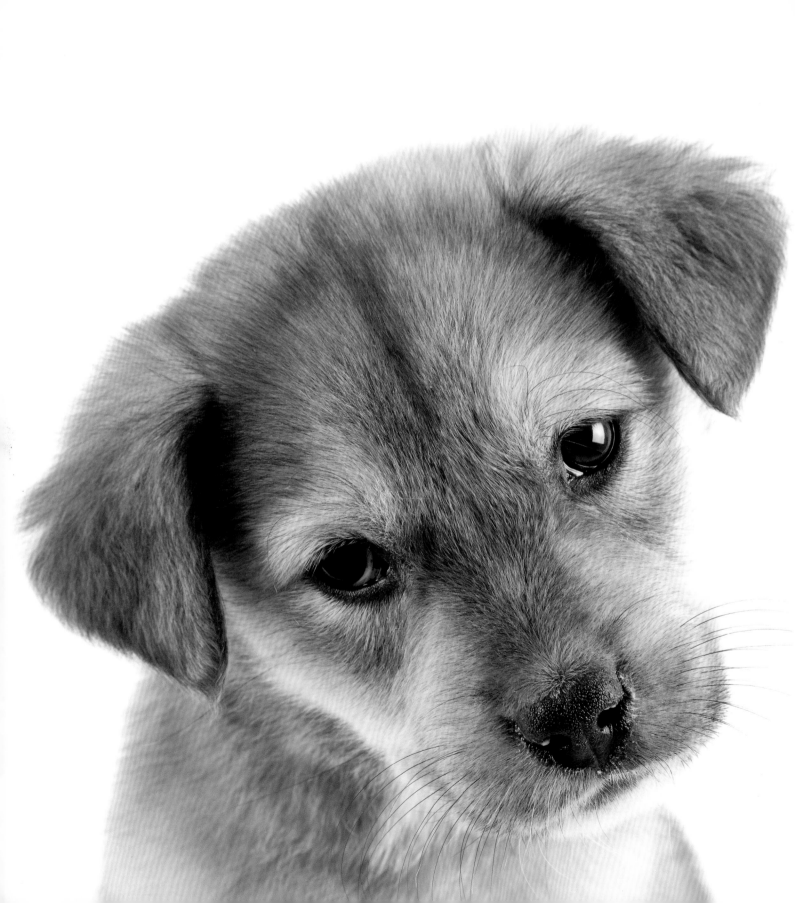

SHELTER
puppies

Mandy

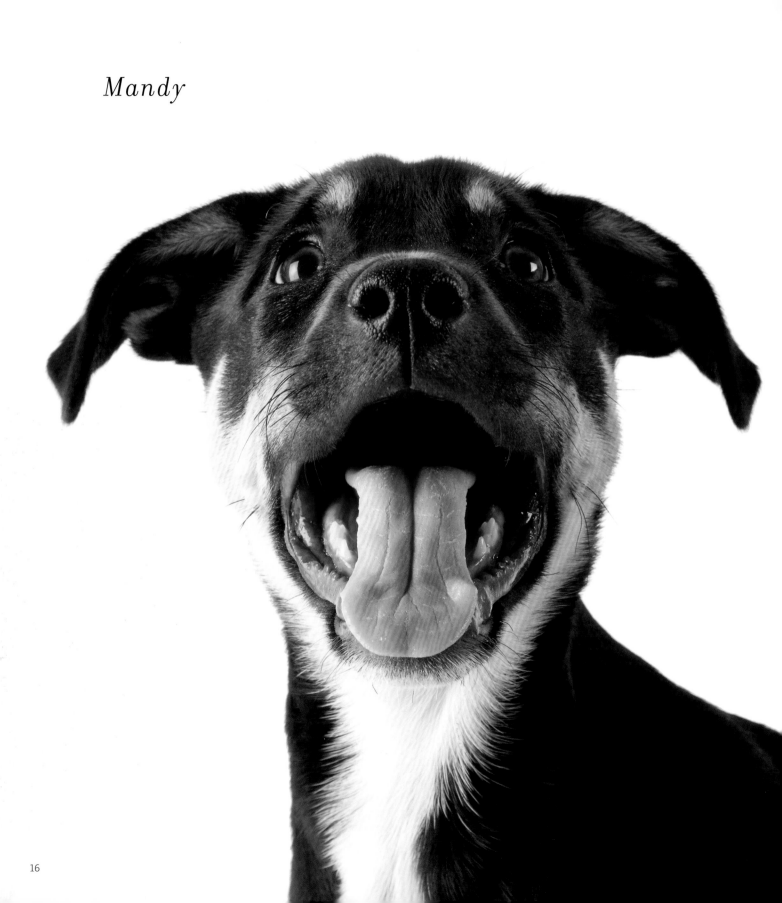

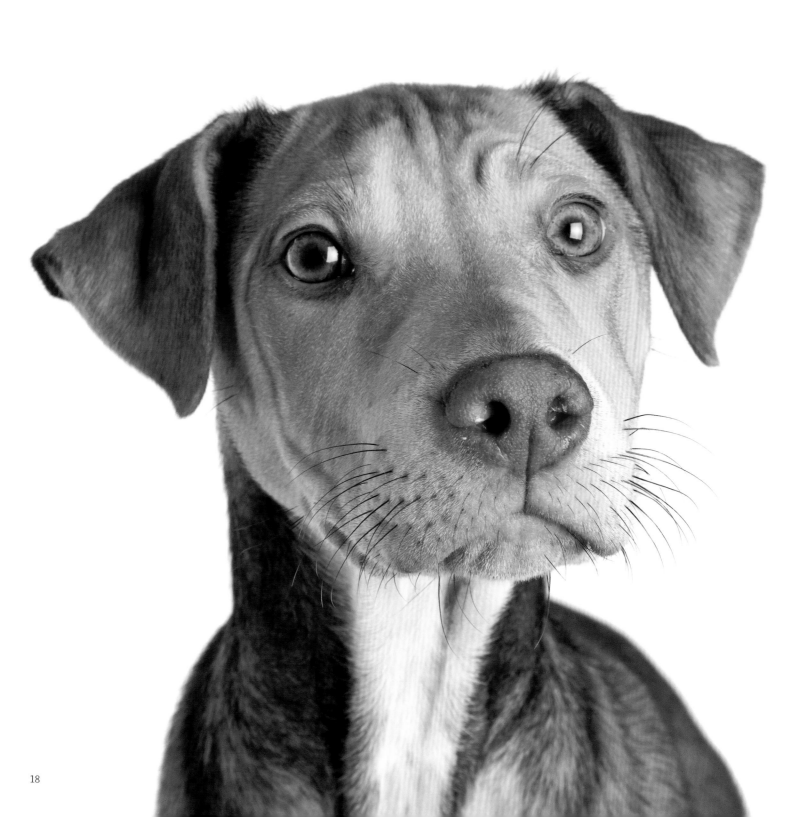

Dueger

Dueger is a great example of what the
Benton-Franklin Humane Society is all about.
He was adopted as a puppy and then returned
to us after a short time. It was clear that
he was not a good fit in his previous home.
After a lot of time and effort by the staff
and volunteers, Dueger worked through
his issues and became highly adoptable.
It took eight months after his being returned,
but he is now in his "forever home" and will
not soon be forgotten by those at our shelter.

Ed Dawson, BFHS Operations Manager

Lilly

Lilly was found by shelter staff underneath one of their trucks, suffering from multiple abrasions. She was immediately taken to the veterinarian, who said that the injuries were consistent with being thrown from a moving vehicle. Despite this rough start, Lilly was incredibly sweet and affectionate.

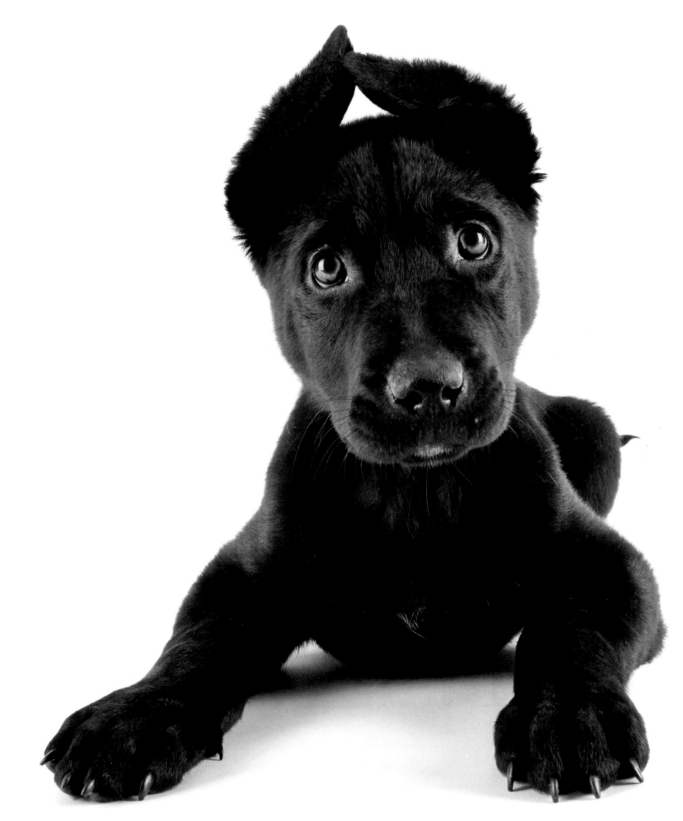

Betty

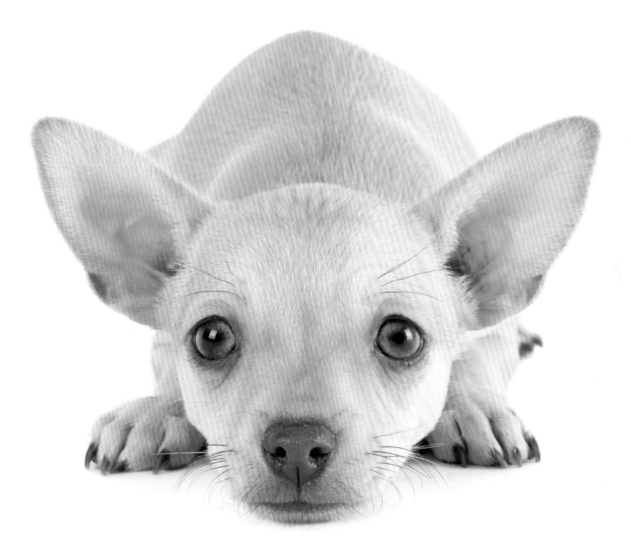

Spike Lee

Spike Lee's energy was apparent from the start of our photographic session, and he bubbled over with personality. It surprised me that it took him as long as it did to find a home.

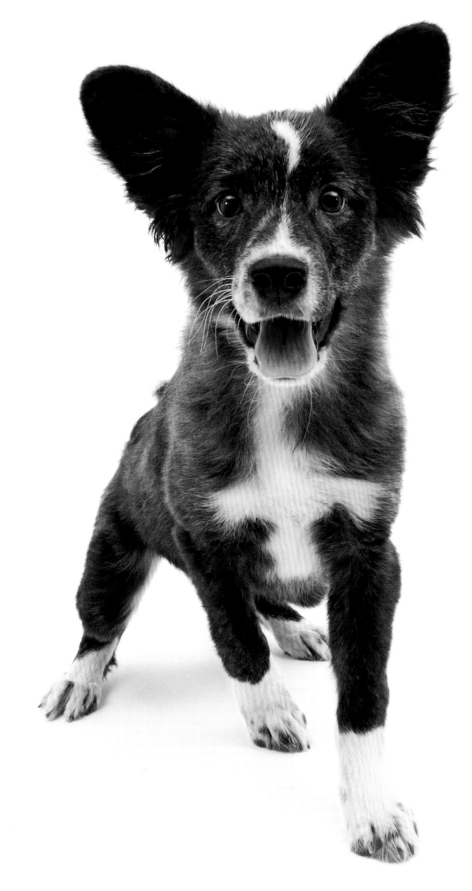

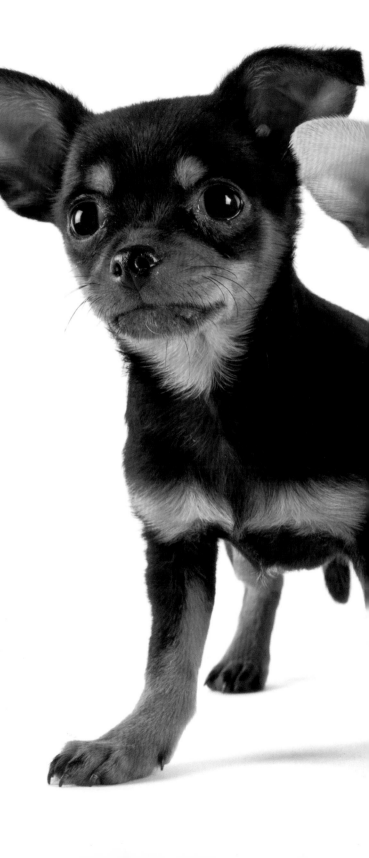

Daisy C's puppies

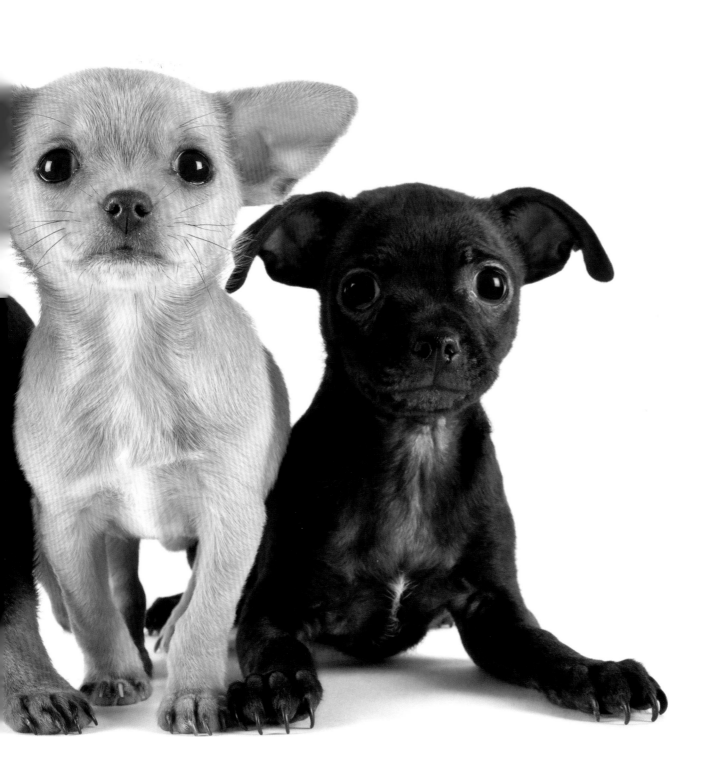

Jerry

We've never loved a dog like this.
Our little man Jerry is family, a true best friend.
We knew he was ours the moment we saw this
picture online, and we drove halfway across the
state to adopt him. His charm and affection
have filled our lives with joy ever since.

Terra and Jason Kelly

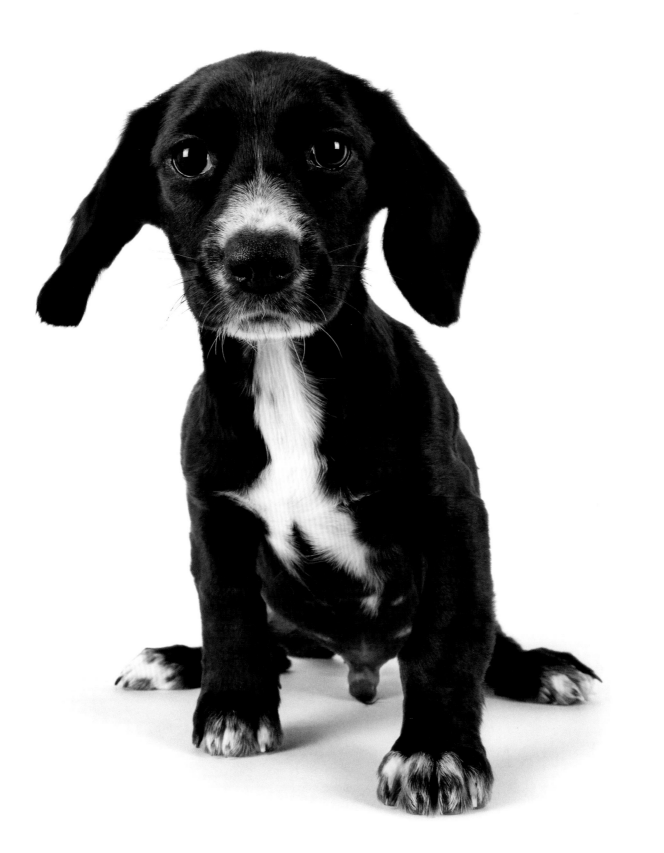

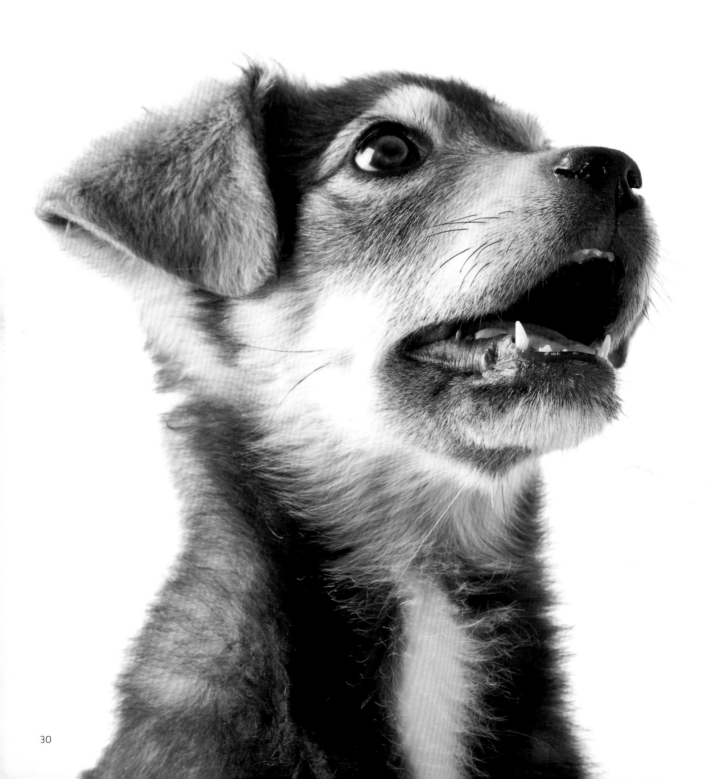

Angel

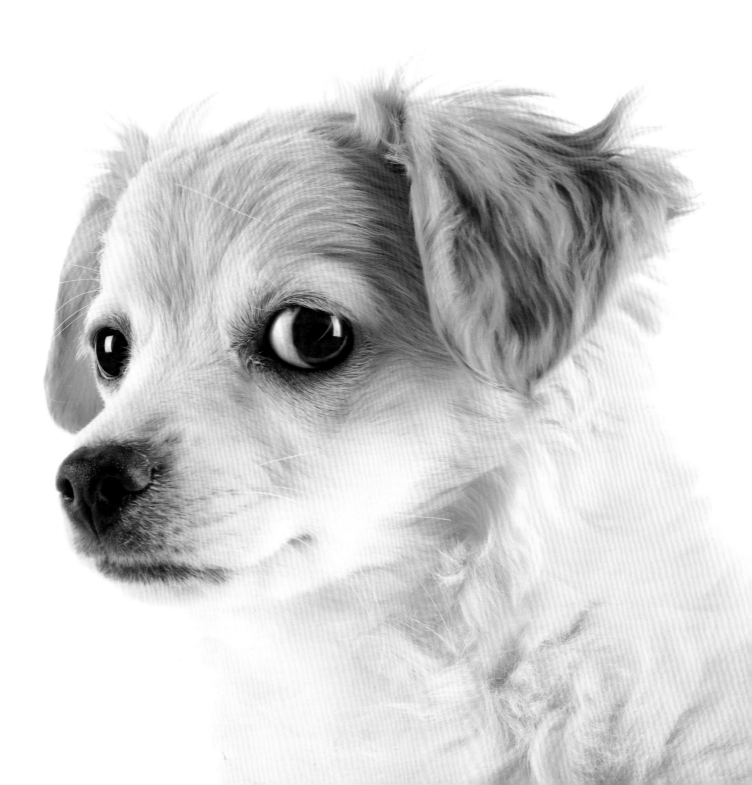

Lil' Bud

Snoopy was the first from her litter to be adopted, but was returned less than a week later with injuries. She was adopted by her new family the same day I photographed her.

Snoopy

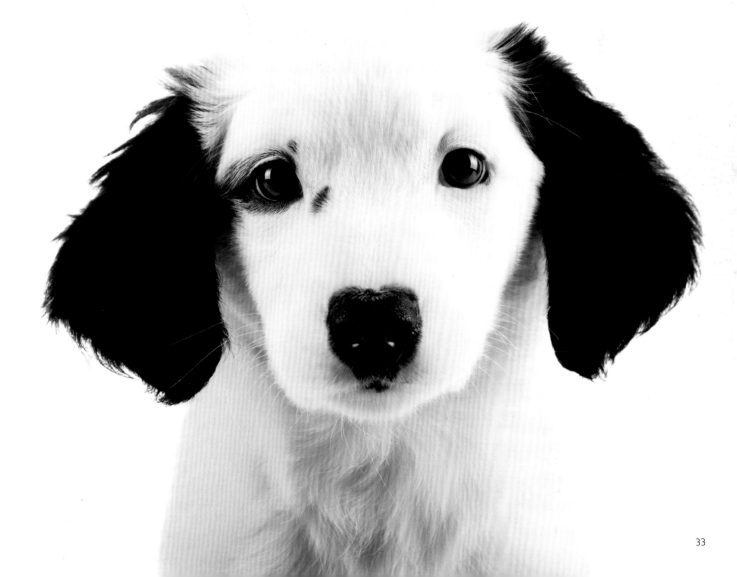

Harley

Harley's mother, Maralee, was abandoned
by her family when her owners moved.
The neighbors realized Maralee was left behind
and cared for her until there was room at the
humane society. Maralee was halfway through
her pregnancy when she was brought in.
By the time Harley and her sisters
were eight weeks old, they were already
as big as their mother.

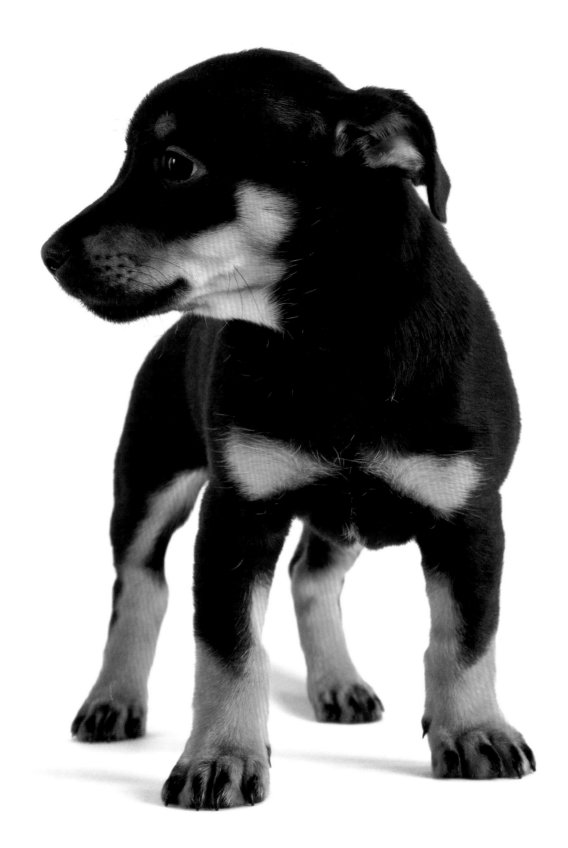

Border collie/St. Bernard mix

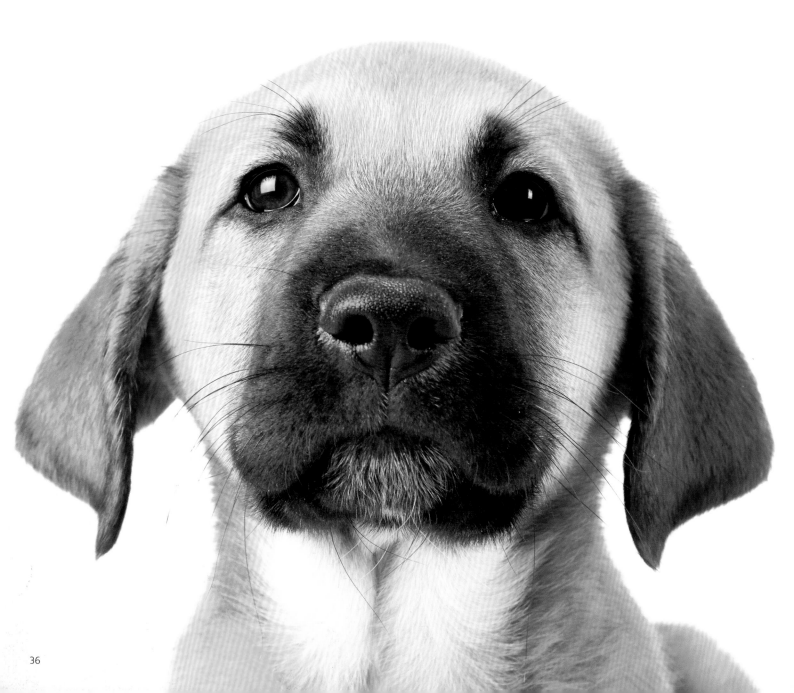

Sebastian

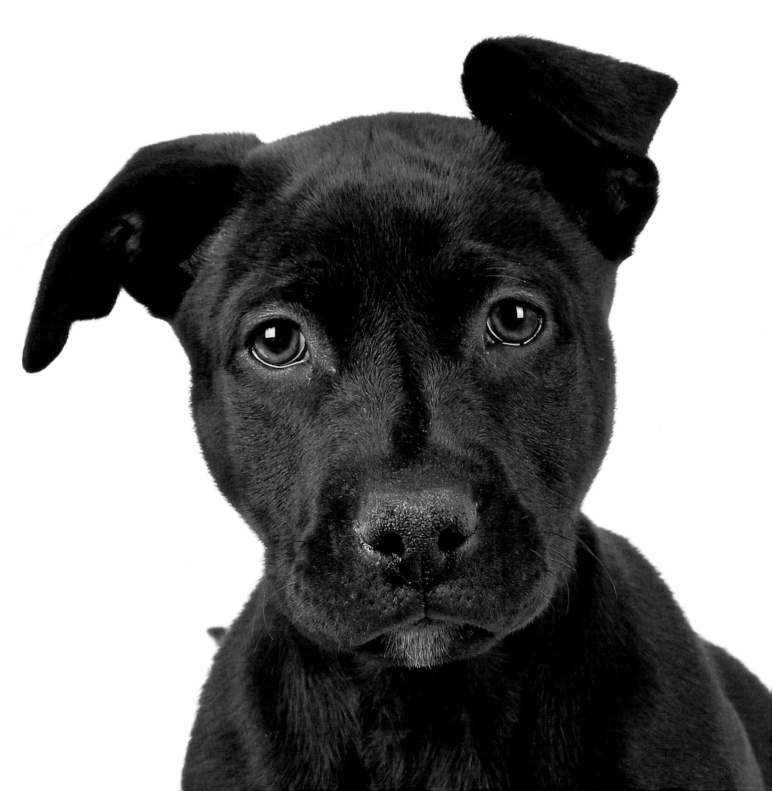

Jasper

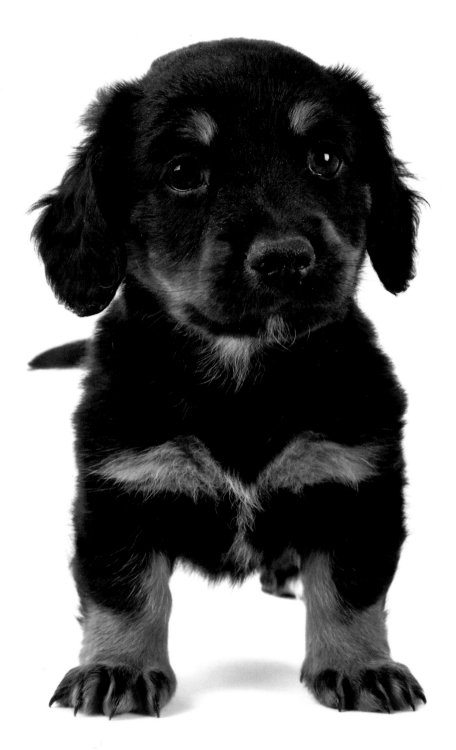

Border terrier/schnauzer mix

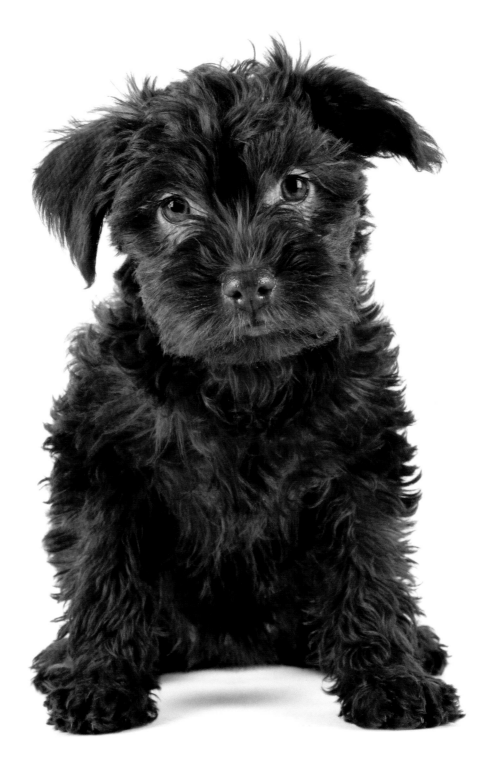

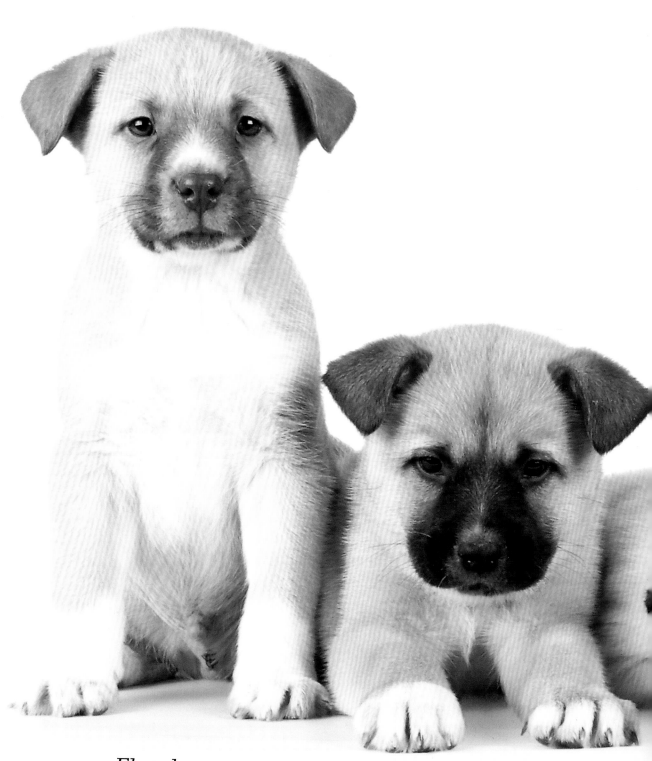

Fletcher

Fabian

*Working with an entire litter at a time
can be very challenging, especially
when coping without an assistant.
The "F-Puppies" stand out as
perhaps the easiest puppies
I've ever photographed.*

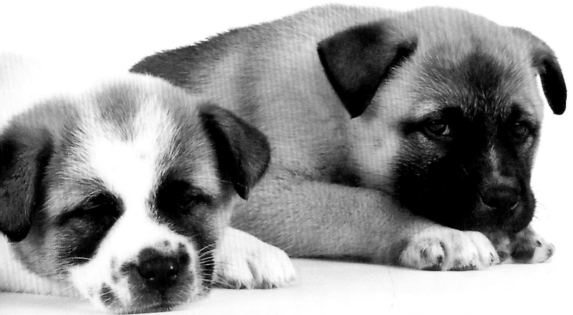

Frankie

Farrah

Cole B

Black puppies (and dogs) often take longer to be adopted than puppies of other colors. Cole B's inquisitive and outgoing personality ensured that he quickly found a home.

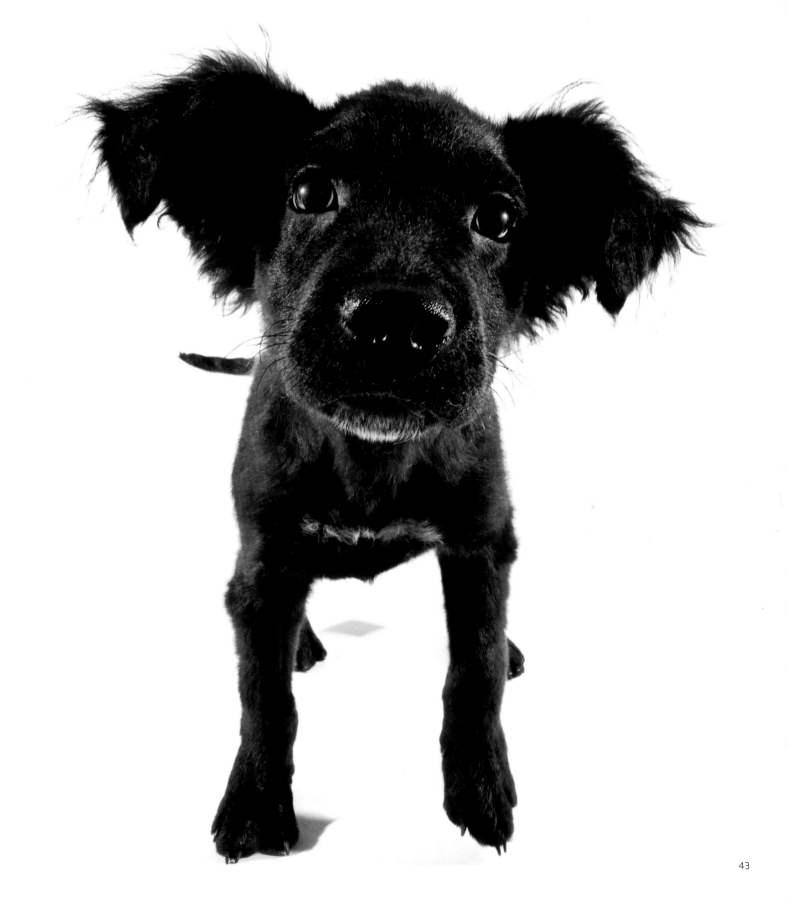

Labrador/golden retriever/shar-pei mix

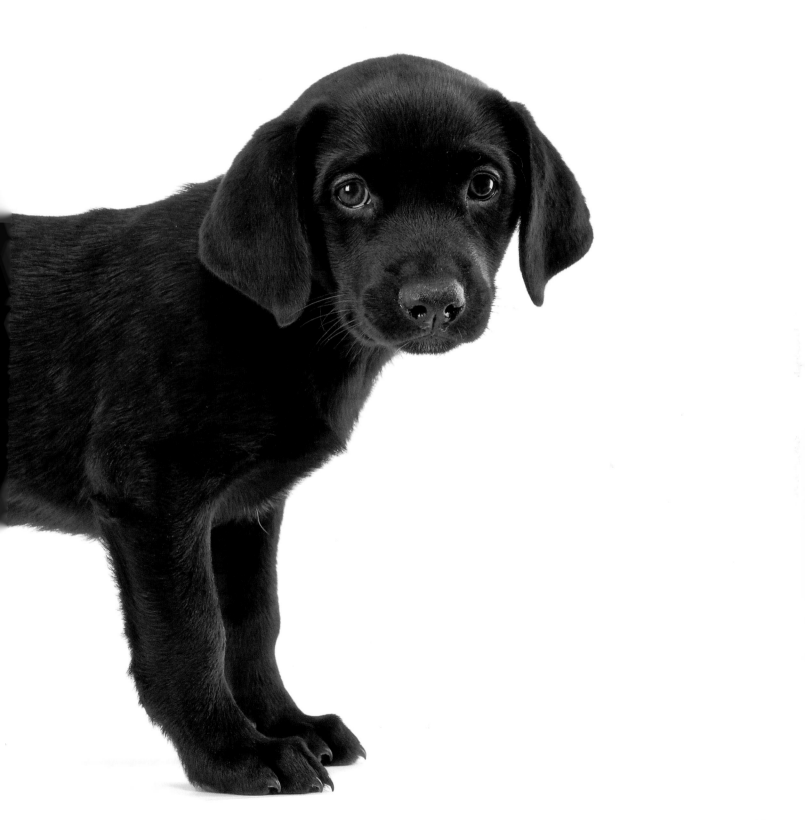

Terrier mix

Bagel

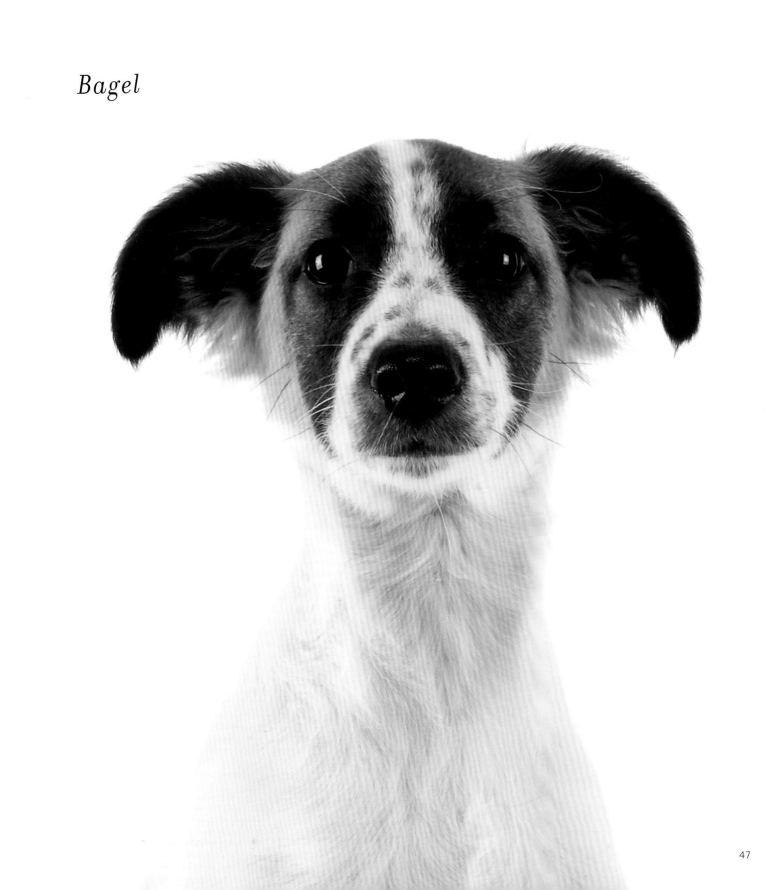

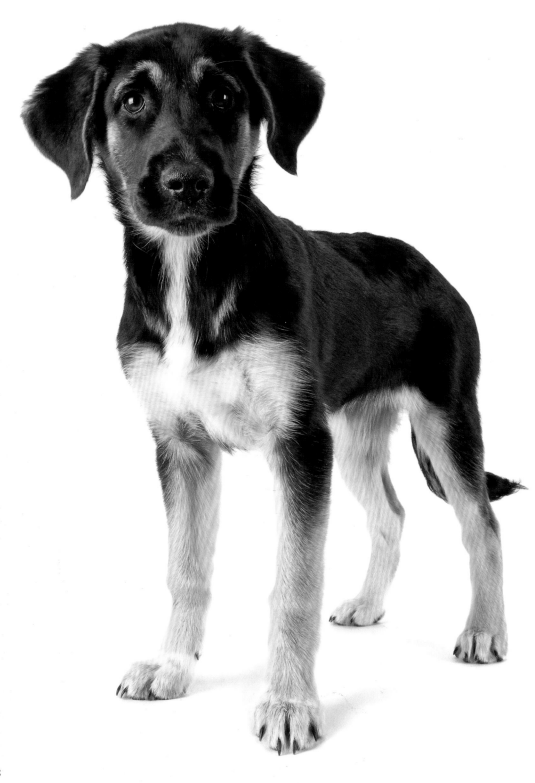

Dixie

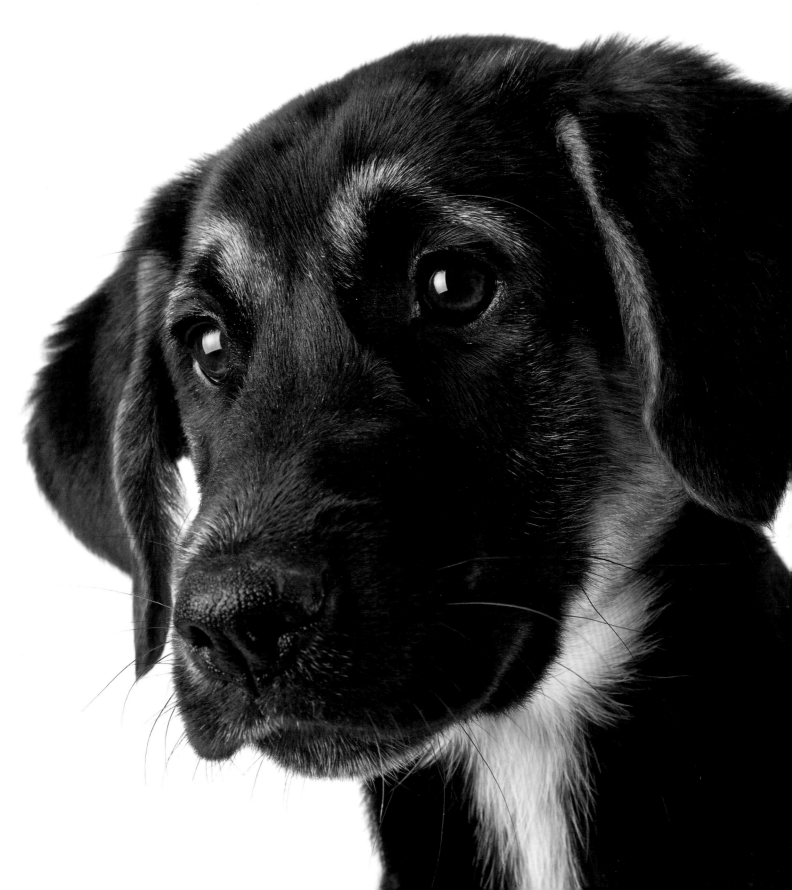

Winston

Winston is a ball of energy,
and he is such a fun puppy!
He provides a lot of entertainment
for my kids.

Meghan Rickard

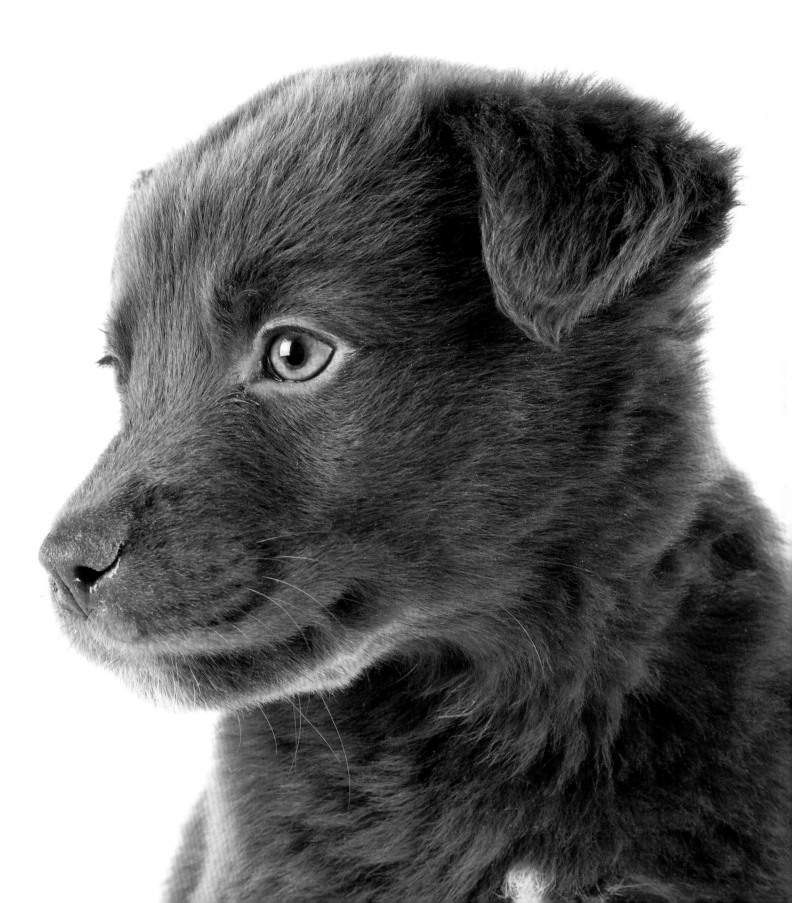

German shepherd mix

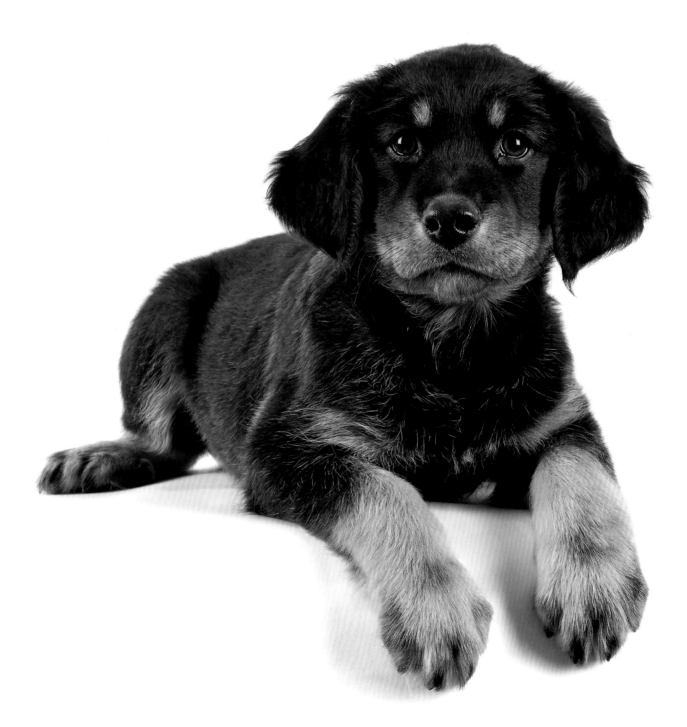

Penelope's golden-pawed puppy

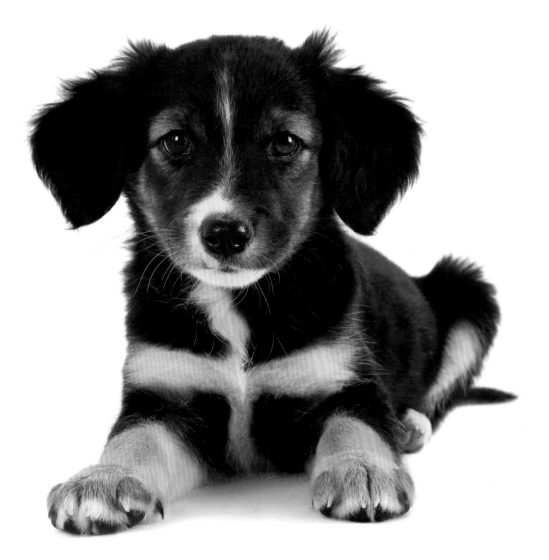

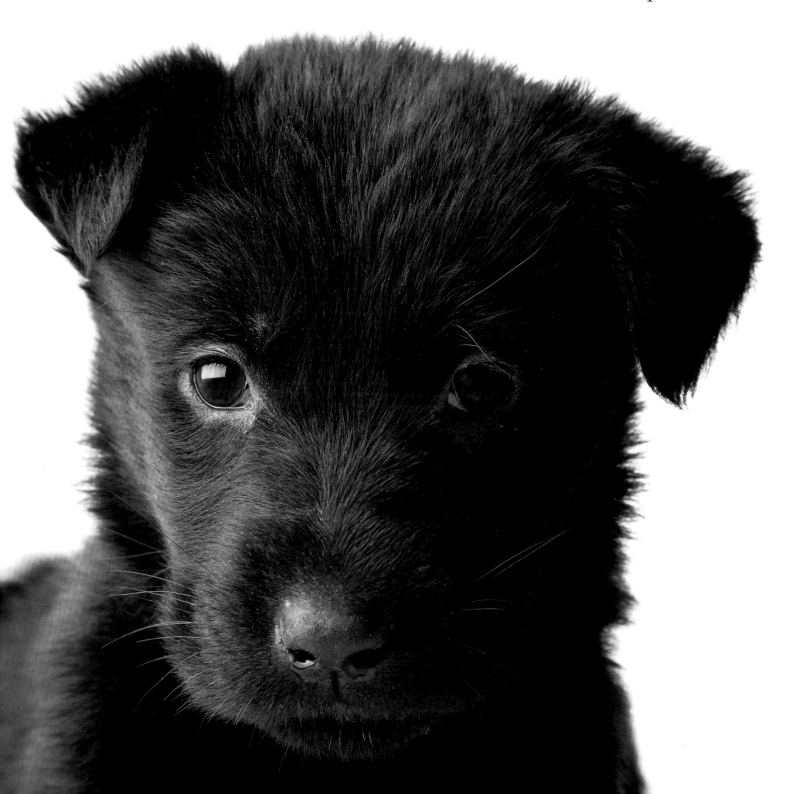

Labrador/German shepherd mix

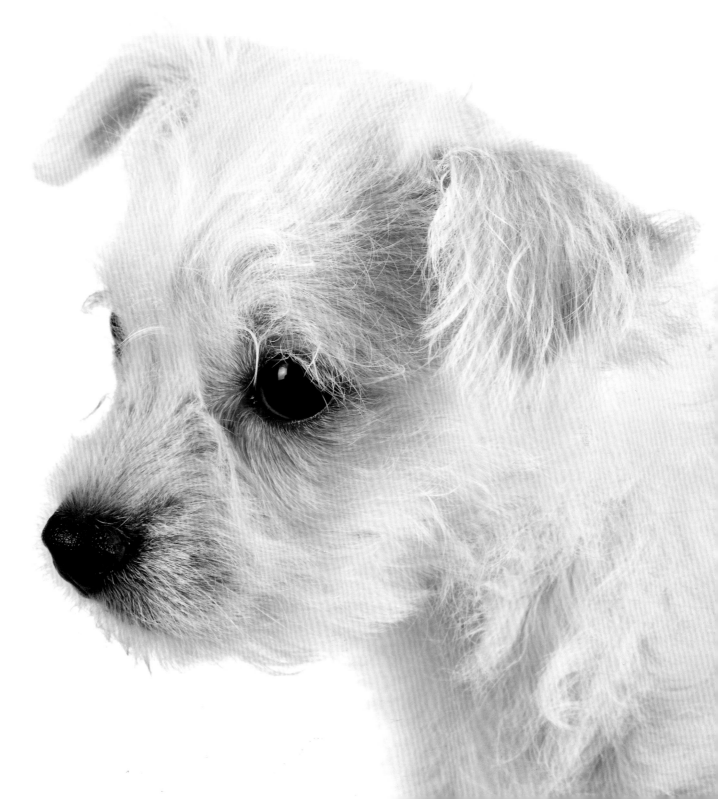

Annie

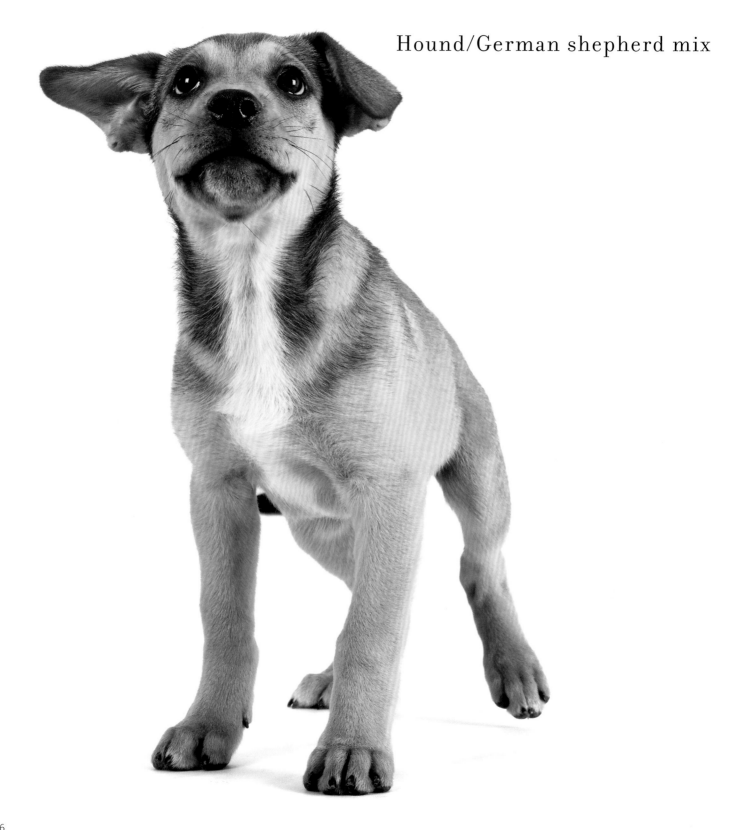

Hound/German shepherd mix

Border collie mix

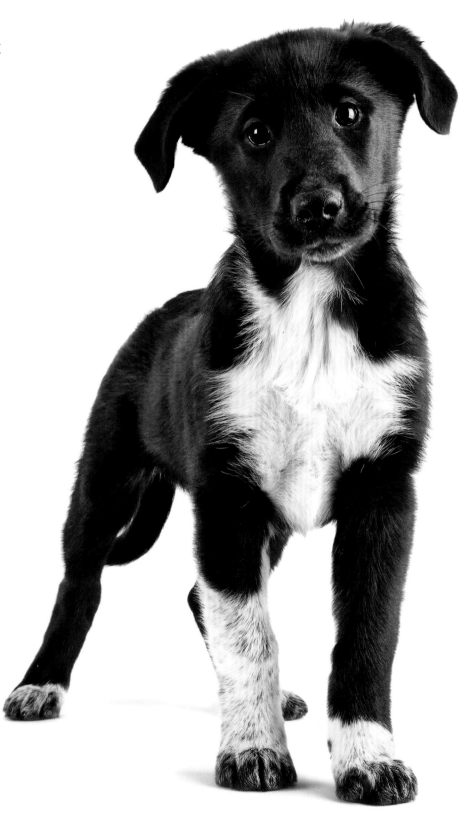

Chow chow/miniature pinscher mix

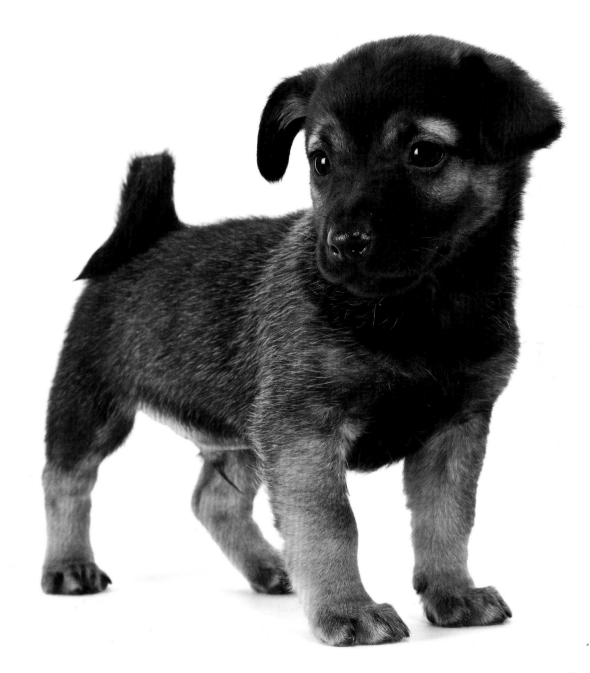

Boston terrier mix

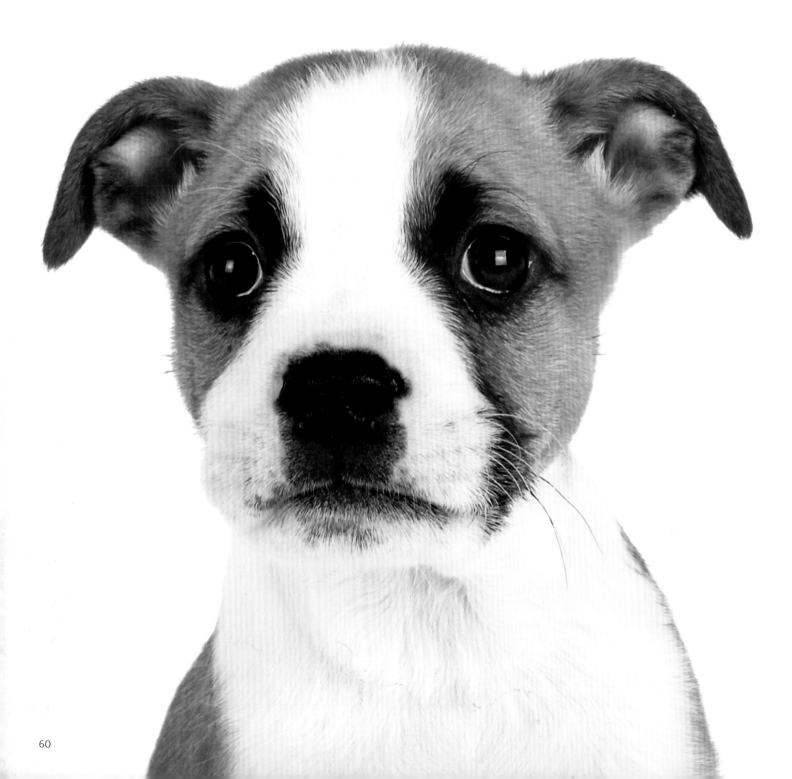

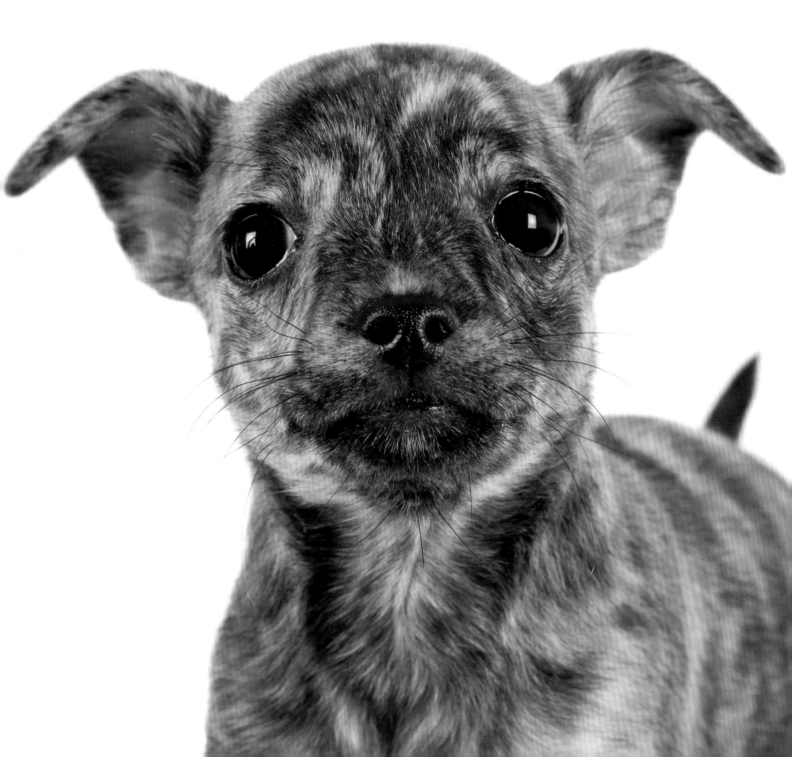

Sleeping Beauty

Penelope's white-pawed puppy

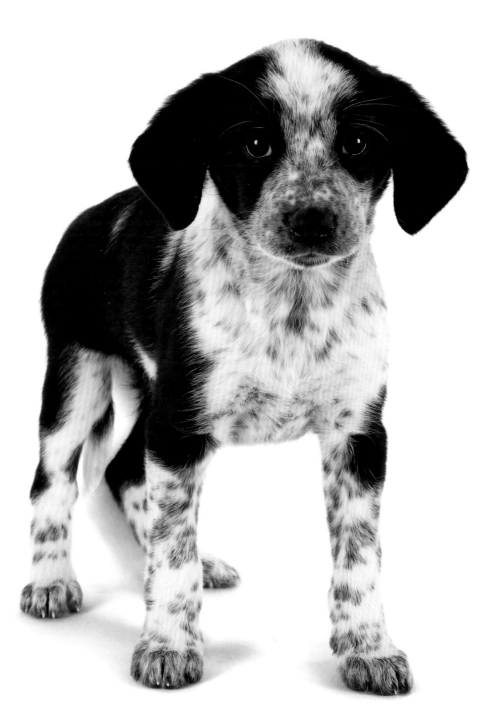

Labrador puppy

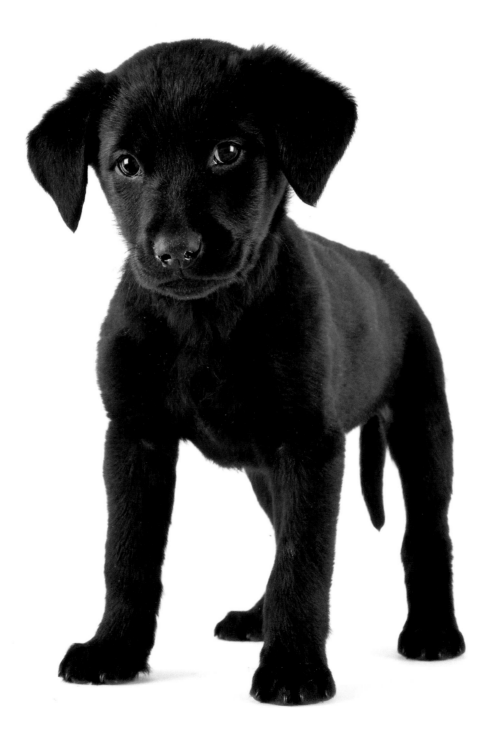

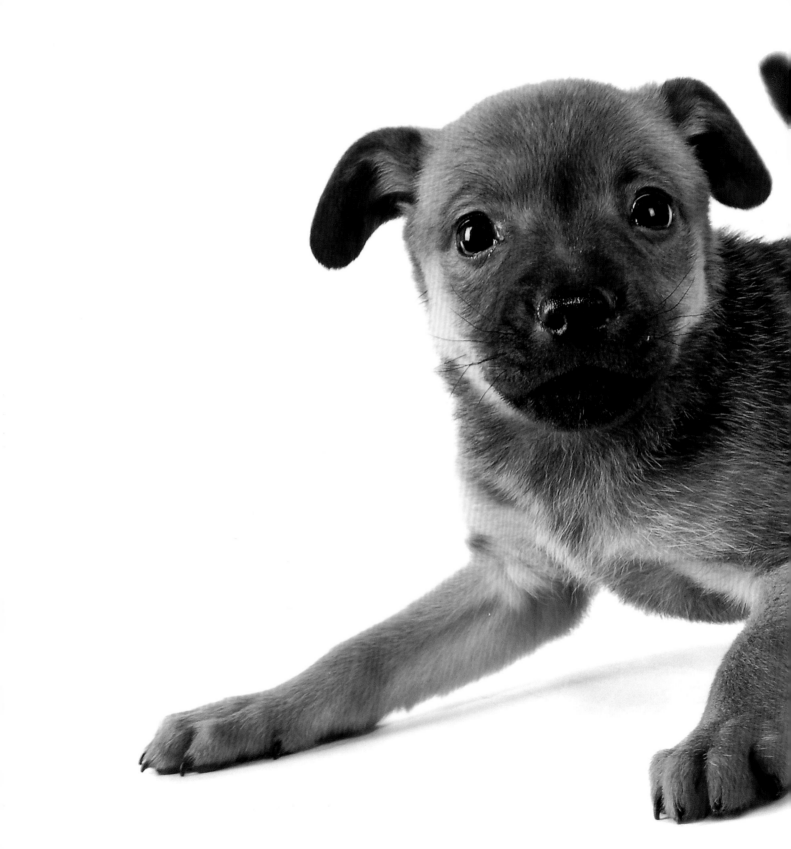

Chow chow/miniature pinscher mix

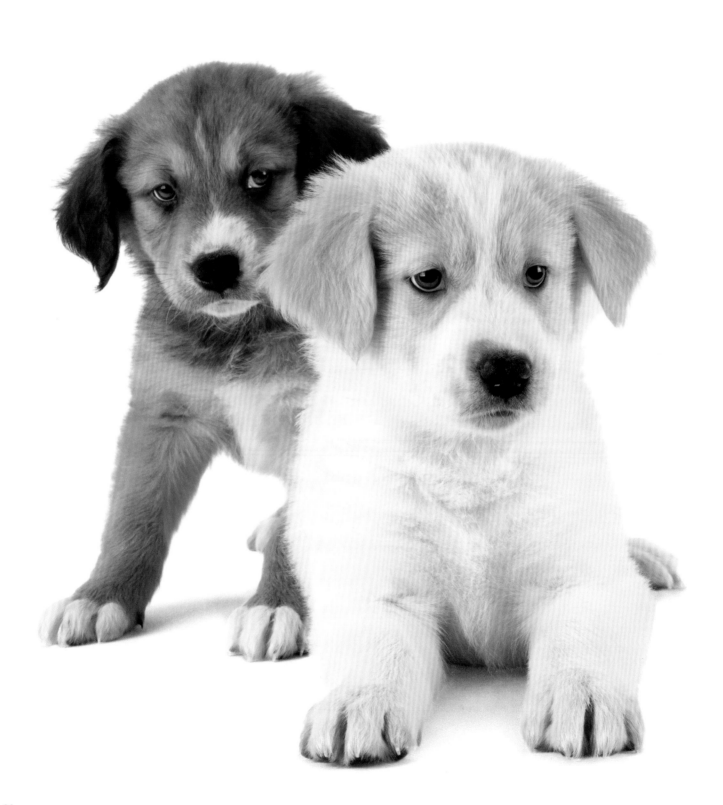

Labrador/rottweiler mixes

Shelter staff sometimes have to make a "best guess" at the breed of puppies. Some guesses are likely to be incorrect, and this may affect the adoptability of a dog. These puppies were listed as Labrador/rottweiler mixes, making them potentially illegal to own in areas with Breed-Specific Legislation (BSL).

Chihuahua/terrier mix

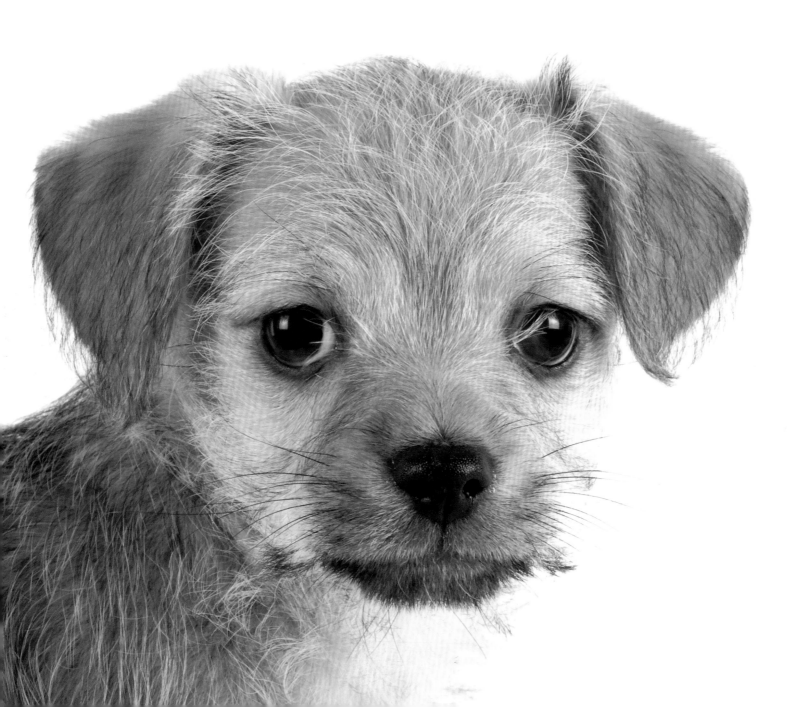

Labrador mix

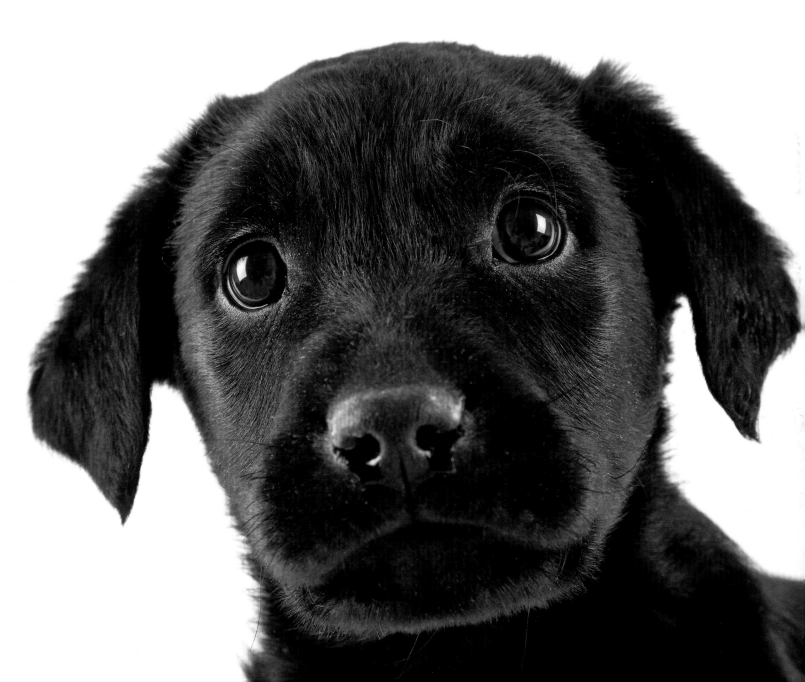

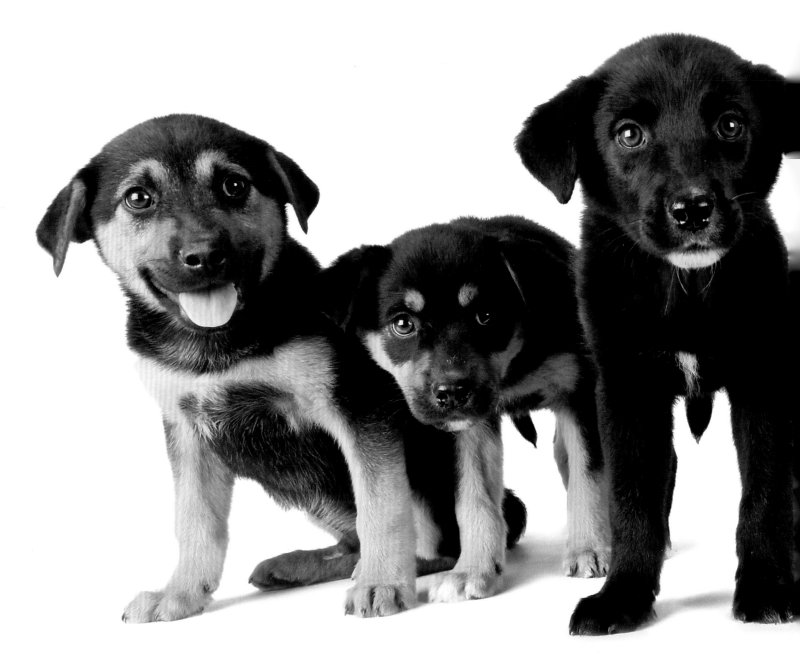

Rambo

Ramona

Rosabella

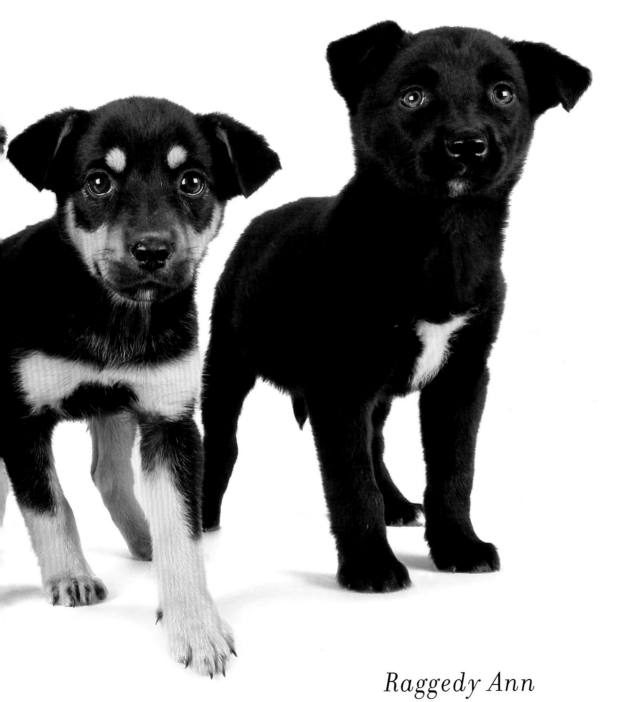

Roxanne

Raggedy Ann

Bella

The first time we saw Bella she put a smile on our faces and warmed our hearts. Who would have guessed that this sweet little gal could fill our home with such joy and energy?

Ronda Medina

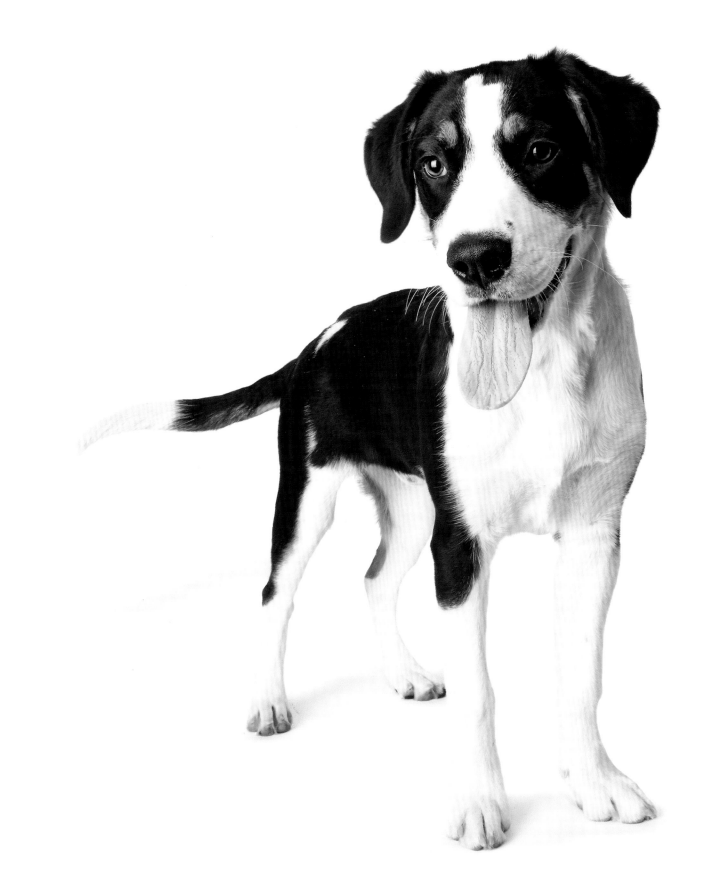

Chihuahua mix

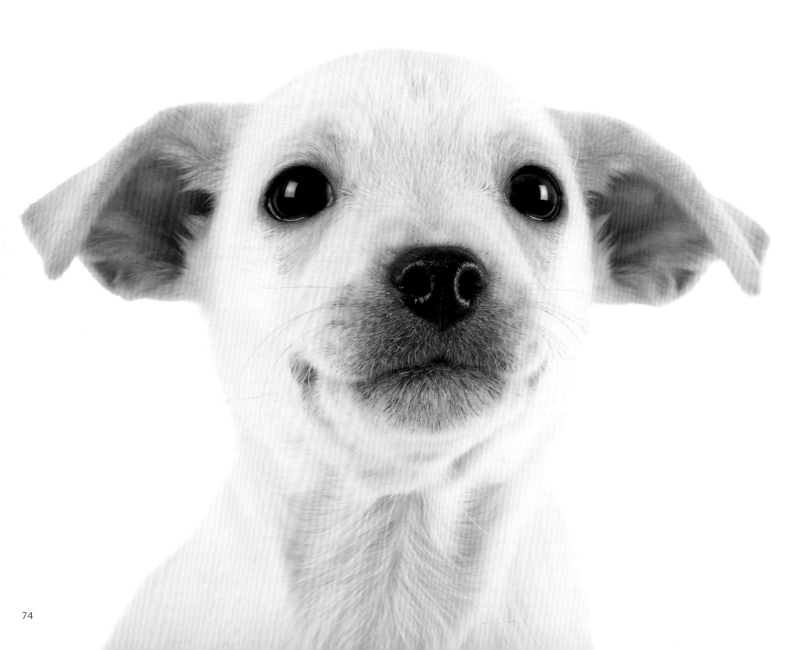

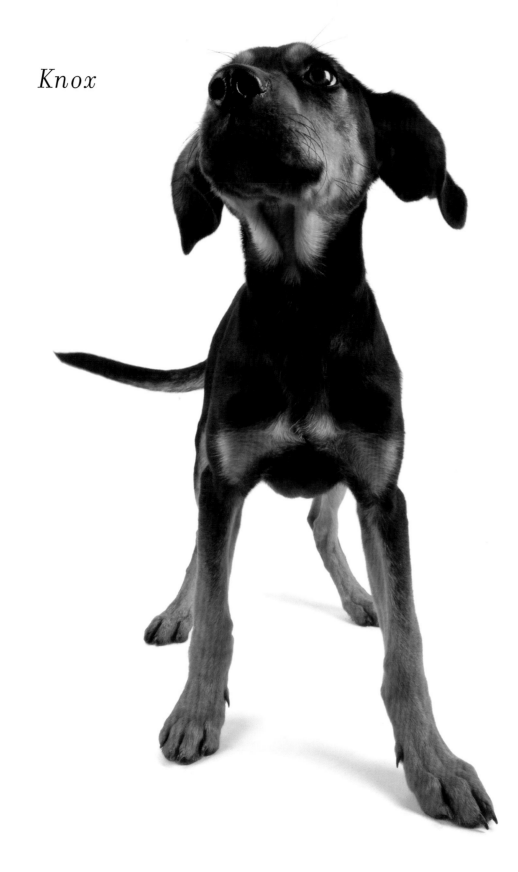

Knox

Princess

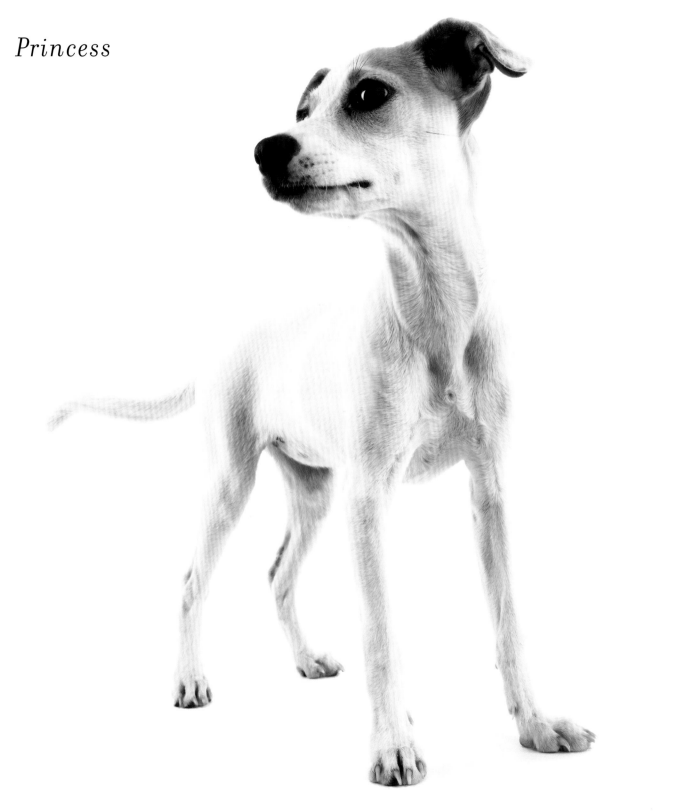

Terrier mix

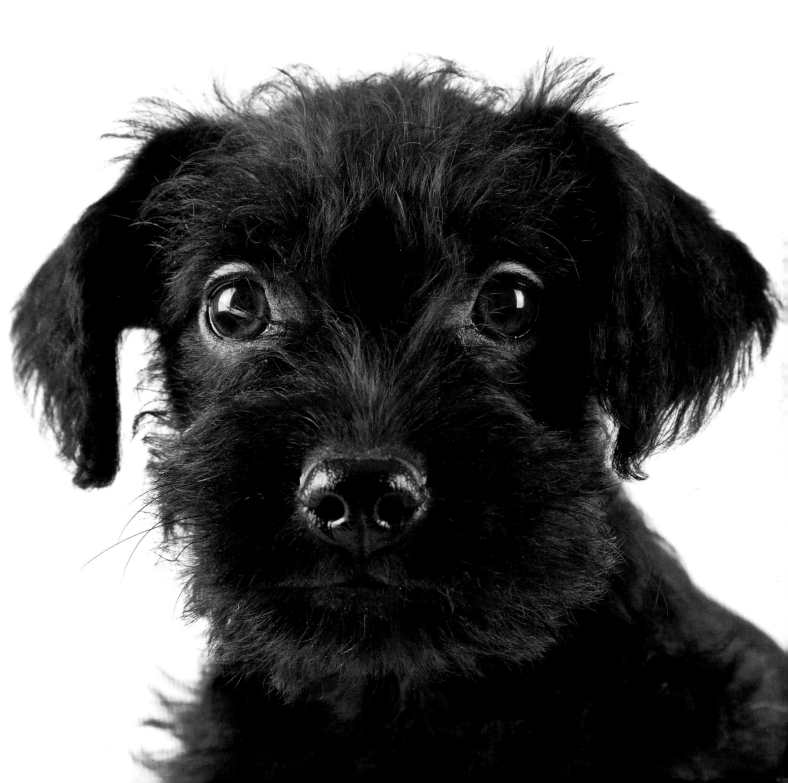

Border terrier/schnauzer mix

Labrador mix

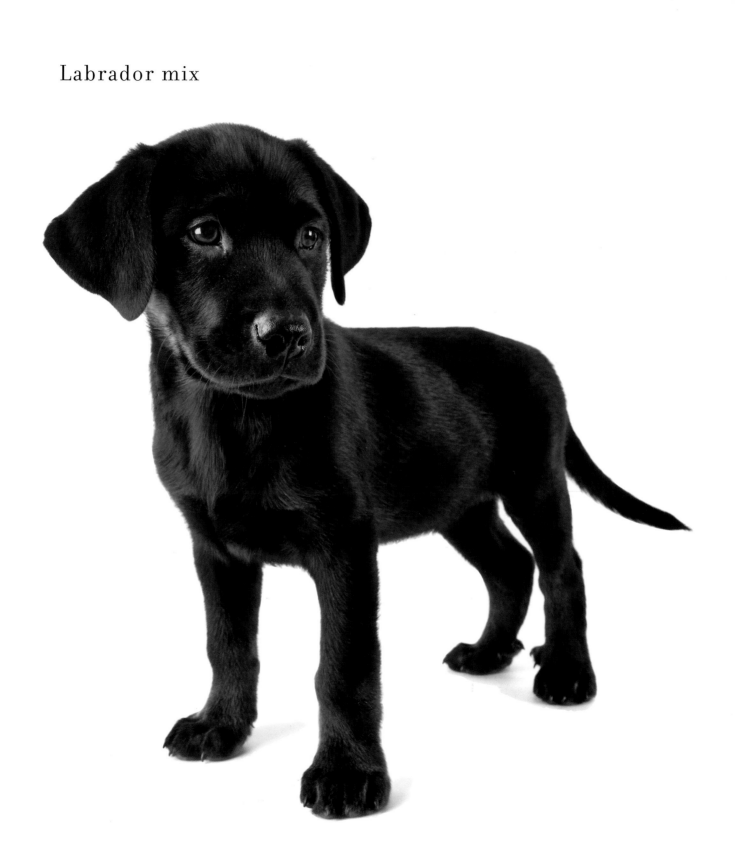

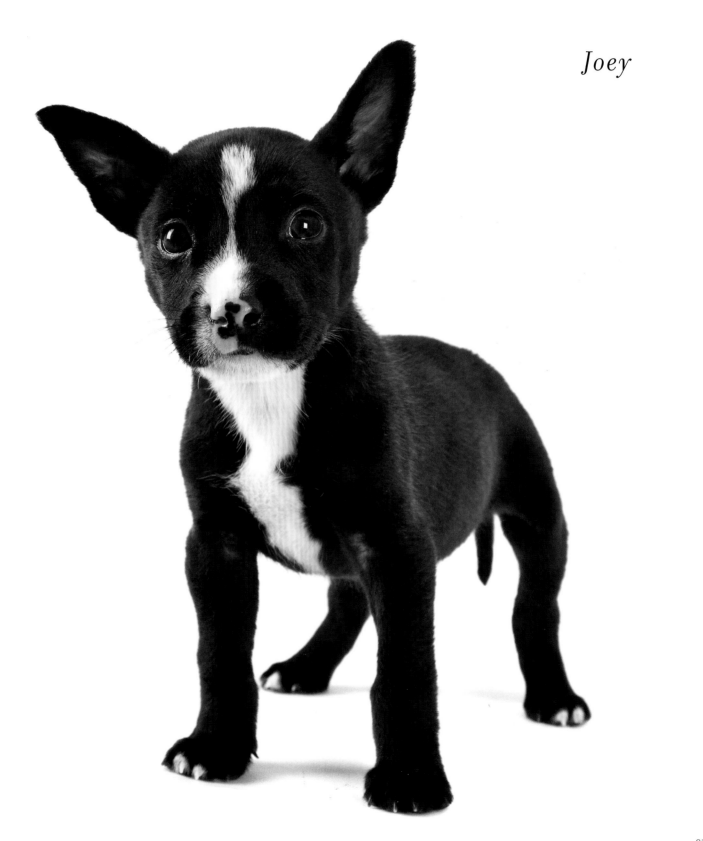

Joey

Golden retriever/Labrador/shar-pei mix

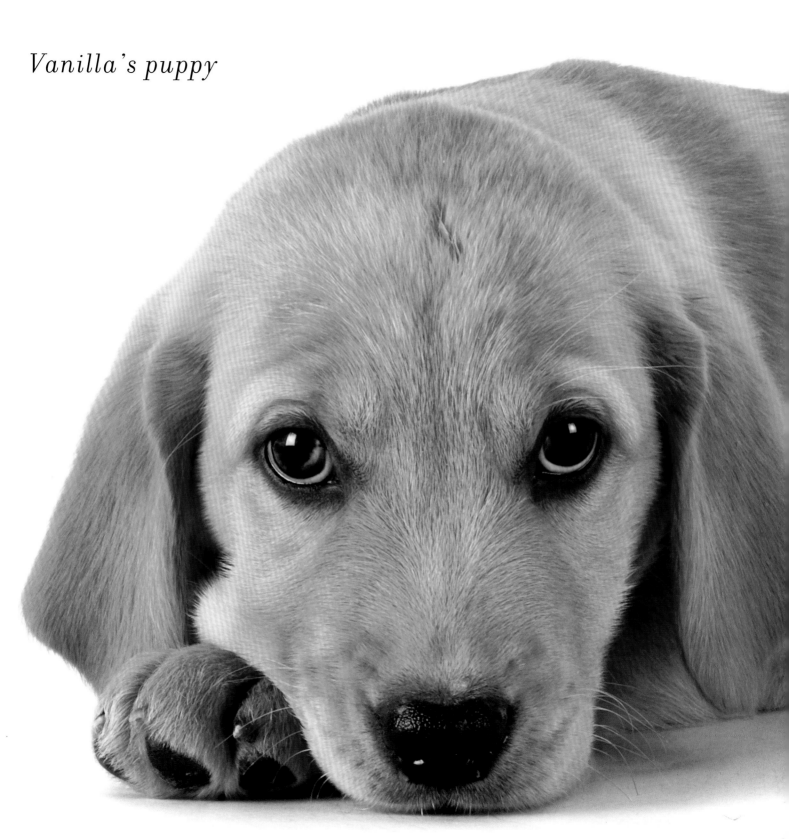

Vanilla's puppy

German shepherd mix

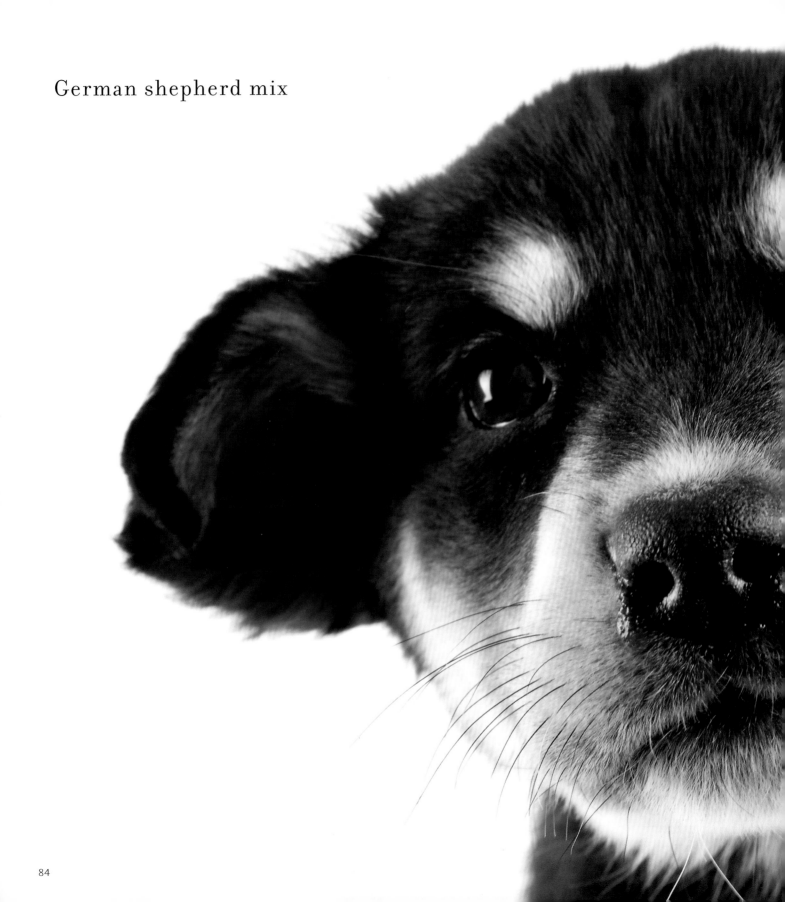

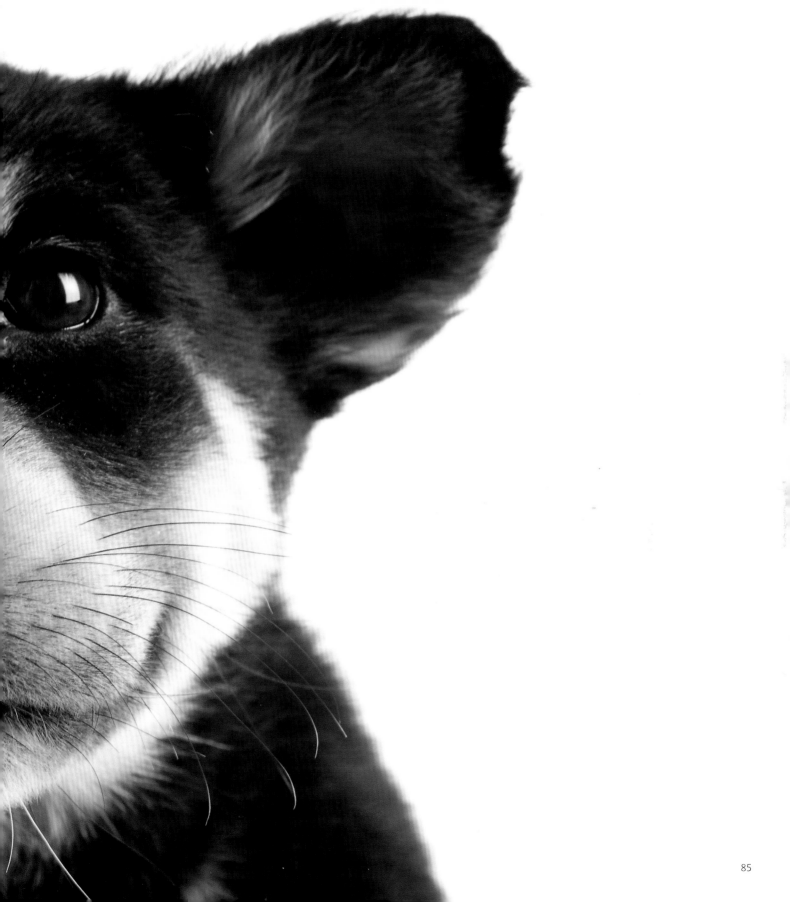

Who's who

These biographies are based on information provided by the various animal shelters. Each shelter records information about the puppies in its care differently.

PAGES 2, 39: *Border terrier/schnauzer mix*
This eight-week-old puppy arrived with his mother and three littermates (see page 79). They lived in foster care until the puppies reached eight weeks and were put up for adoption. He was adopted after six days.

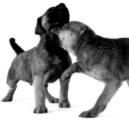

PAGES 4–5: *Chow chow/miniature pinscher mixes*
These eight-week-old puppies were brought in with three littermates. They were very vocal and playful, and were all adopted within eleven days.

PAGE 14: *Maxwell*
Shepherd mix Maxwell was eight weeks old when I first photographed him, and he was adopted three days later. He was returned to the shelter at four months old because his owner could not handle him. He was adopted into a new home after five days.

PAGE 16: *Mandy*
Three-month-old Labrador/rottweiler mix Mandy was as good-natured a puppy as I've ever met. She spent less than a week at the shelter before she was adopted.

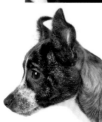

PAGE 17: *Linus*
Twelve-week-old Chihuahua mix Linus was adopted after six days.

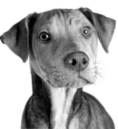

PAGE 18: *Dueger*
Five-month-old shar-pei mix Dueger was originally adopted quickly but was returned a few months later because he was too energetic for his family. He received some training at the shelter, but waited eight months before he was adopted into a new home.

PAGE 21: *Lilly*
Labrador/German shepherd mix Lilly was about three months old when she was found by shelter staff injured and frightened. She was treated for minor abrasions and was adopted after twelve days.

PAGES 22, 23: *Betty*
Chihuahua mix Betty was eight and a half weeks old when I photographed her and her two littermates. She was the last of her litter to be adopted, after seventeen days.

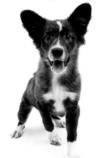

PAGE 25: *Spike Lee*
Nine-week-old border collie/retriever mix Spike Lee was brought to Woodford with his brother, Cole B (page 43). Despite his outgoing personality, it took him sixty days to get adopted.

PAGES 26–27:
Daisy C's puppies
These Chihuahua mixes were born and raised in foster care, and were brought to the shelter for adoption at ten weeks old. That is when it was discovered that the tan puppy had some medical difficulties; at the time of writing, she is living in foster care with a veterinary technician. The other two puppies were adopted about a week after they arrived at the shelter.

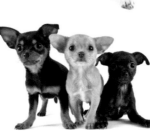

PAGE 29: *Jerry*
Ten-week-old border collie mix Jerry was quickly adopted by a family who had seen his adoption profile online. His family made a 500-mile round-trip to adopt him.

PAGE 30: *Angel*
Fourteen-week-old Labrador/border collie mix Angel was surrendered with her brother. She was adopted after six days.

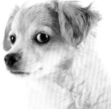

PAGE 31: *Lil' Bud*
Three-month-old Chihuahua mix Lil' Bud was surrendered with his brother. He was adopted after two days.

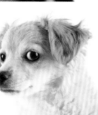

PAGES 32, 33: *Snoopy*
Nine-week-old border collie mix Snoopy was born in foster care after her pregnant mother was surrendered to the humane society. She was adopted a day after becoming available for adoption, but was returned a few days later. She was adopted into a new home after two days.

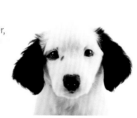

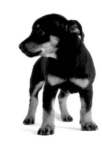

PAGE 35: *Harley*
Chihuahua mix Harley was born in foster care after her pregnant mother was abandoned by her owner and brought to Benton-Franklin Humane Society by a neighbor. She was photographed at eight weeks old and was adopted after eight days.

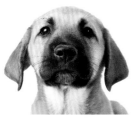

PAGE 36: *Border collie/ St. Bernard mix*
This nine-week-old puppy was surrendered with five littermates. He was adopted in less than a week.

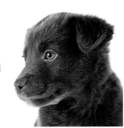

PAGE 43: *Cole B*
Nine-week-old border collie/retriever mix Cole B was brought to Woodford with his brother, Spike Lee (page 25). He was adopted after eleven days.

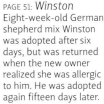

PAGE 51: *Winston*
Eight-week-old German shepherd mix Winston was adopted after six days, but was returned when the new owner realized she was allergic to him. He was adopted again fifteen days later.

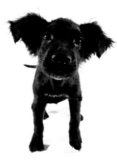

PAGE 37: *Sebastian*
Nine-week-old Labrador mix Sebastian was surrendered with his brother. He was adopted in less than three weeks.

PAGES 44–45:
Labrador/golden retriever/shar-pei mix
This eight-week-old puppy was adopted after seven days.

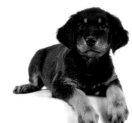

PAGE 52: *German shepherd mix*
This nine-week-old German shepherd mix was surrendered with three littermates. He was adopted after sixteen days.

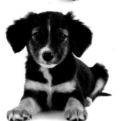

PAGE 38: *Jasper*
Seven-week-old dachshund/red heeler mix Jasper was surrendered with his two sisters. He was adopted after five days.

PAGE 46: *Terrier mix*
This eight-week-old wire terrier mix was adopted after nine days.

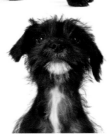

PAGE 53: *Penelope's golden-pawed puppy*
This nine-week-old border collie mix is a littermate of Snoopy (pages 32, 33). He was born in foster care, and was adopted nineteen days after he was old enough to be away from his mother.

PAGE 39: *see page 2*

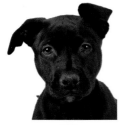

PAGES 40–41: *Fletcher, Fabian, Farrah, Frankie*
The "F Puppies," eight-week-old German shepherd/hound mixes, were one of the few litters I brought to my home studio to photograph. Fletcher, on the far left, was obviously the pack leader, and the four played with one another until they were tired. They were all adopted within thirteen days.

PAGE 47: *Bagel*
Shortly after four-and-a-half-month-old Brittany spaniel/papillon mix Bagel was surrendered to BFHS, he was found to have ringworm and was isolated for treatment. His total stay approached two months, but he was adopted eight days after his health issues were resolved.

PAGE 54:
Labrador/German shepherd mix
This nine-week-old puppy was surrendered with three littermates. He was adopted after sixteen days.

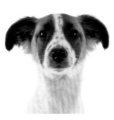

PAGES 48, 49: *Dixie*
German shepherd mix Dixie was three months old when she was surrendered to BFHS. She was adopted after ten days.

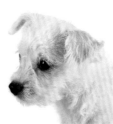

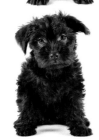

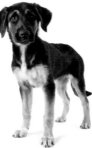

PAGE 55: *Annie*
Eight-week-old Annie, a Chihuahua/terrier mix, was surrendered with six littermates. She was adopted after four days.

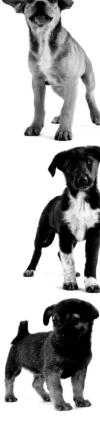

PAGE 56: *Hound/German shepherd mix*
This puppy was eight weeks old when he was surrendered with his four littermates. He was adopted after eight days.

PAGE 62:
Penelope's white-pawed puppy
This nine-week-old border collie mix is a littermate of Snoopy (pages 32, 33). She was born in foster care and was adopted eight days after she was old enough to be away from her mother.

PAGE 69: *Labrador mix*
This eight-week-old puppy was adopted after fifteen days.

PAGE 57: *Border collie mix*
This ten-week-old puppy was surrendered with eight littermates. She was adopted after thirteen days.

PAGE 63: *Labrador puppy*
This eleven-week-old puppy was transferred to BFHS from another rescue facility, along with three littermates. She was adopted after twenty-three days.

PAGES 70–71:
Rambo, Ramona, Rosabella, Roxanne, Raggedy Ann

These German shepherd/rottweiler mix pups were the last litter of shelter puppies I photographed in my home studio. They were sweet-natured but nervous after the trip from Woodford. They were all adopted within twenty-one days.

PAGES 58, 59: *Chow chow/miniature pinscher mix* This eight-week-old puppy was brought in as one of a litter of five (see pages 4–5, 64–65), and was adopted after three days.

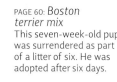

PAGES 64–65: *Chow chow/miniature pinscher mix*
This eight-week-old puppy was the most playful of her littermates (see pages 4–5, 58 and 59), and was adopted after four days.

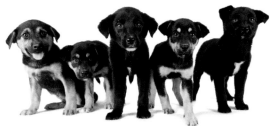

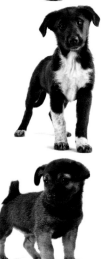

PAGE 60: *Boston terrier mix*
This seven-week-old puppy was surrendered as part of a litter of six. He was adopted after six days.

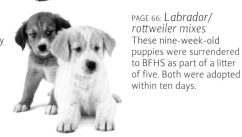

PAGE 66: *Labrador/rottweiler mixes*
These nine-week-old puppies were surrendered to BFHS as part of a litter of five. Both were adopted within ten days.

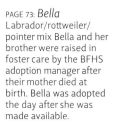

PAGE 73: *Bella*
Labrador/rottweiler/pointer mix Bella and her brother were raised in foster care by the BFHS adoption manager after their mother died at birth. Bella was adopted the day after she was made available.

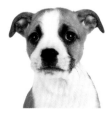

PAGE 61: *Sleeping Beauty*
Sleeping Beauty, an eight-week-old Chihuahua mix, was surrendered with six littermates. She was adopted after two days.

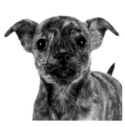

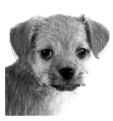

PAGE 68: *Chihuahua/terrier mix*
This eight-week-old puppy was surrendered with four littermates. She was adopted after two days.

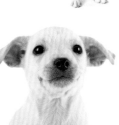

PAGES 74, 75:
Chihuahua mix
This eight-week-old puppy is Betty's sister (see pages 22, 23). She was adopted after five days.

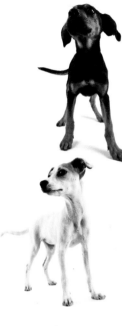

PAGE 76: *Knox*
Knox, a ten-week-old Catahoula/hound mix, was surrendered with his brother. He was adopted after just over a month.

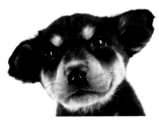

PAGE 80:
Labrador mix
This ten-week-old puppy was adopted after four days.

PAGES 84–85: *German shepherd mix*
This eight-week-old puppy was surrendered as part of a litter of four. She was adopted after five days.

PAGE 77: *Princess*
Chihuahua mix Princess was approximately five months old when she was captured by animal control. She was adopted after ten days.

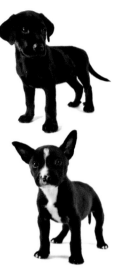

PAGE 81: *Joey*
Bull terrier Joey was ten weeks old when I photographed him. He was adopted after six days.

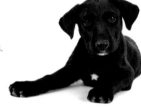

PAGE 96: *Labrador mix*
This puppy was ten weeks old when I photographed her. She was adopted after seventeen days.

PAGE 78: *Terrier mix*
This nine-week-old puppy was surrendered as part of a litter of four. He was adopted after seven days.

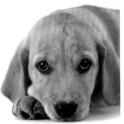

PAGE 82: *Golden retriever/Labrador/ shar-pei mix*
This pup was eight weeks old when he was transferred to BFHS from a neighboring county's rescue center with his four littermates. He was adopted after five days.

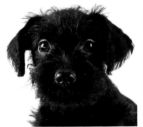

PAGE 79: *Border terrier/ schnauzer mix*
This eight-week-old puppy was brought to BFHS with her mother and three littermates (see pages 2 and 39). She was adopted after ten days.

PAGE 83: *Vanilla's puppy*
This eight-week-old Labrador mix was surrendered with his mother and seven littermates. He was adopted after ten days.

Happy endings

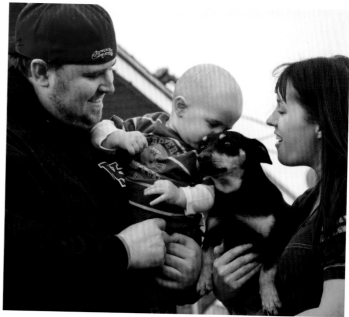

Lil' Bud (page 31)

I sent my husband, Leo, to the humane society to get a Chihuahua that had been taken there by people moving out of the country, but it had already been adopted. Although Leo didn't want a dog, he asked to see a little blond puppy in a cage. When Leo held this puppy, it clung to him and cried when put down. Leo called me and said this was the one he wanted. When I got home from work, I fell instantly in love. This little guy has been a godsend. He loves to go for walks and plays at the park with other dogs. He has fun with all his toys and loves to play with our grandson Peyton. We are always rewarded with puppy kisses when we get home from work. Leo has a heart condition, and Peyton says that Papa is going to live a lot longer now and is not so sad. We love our Lil' Bud with all our hearts and are so happy that Leo found our puppy.

Mr. and Mrs. Leo Stuk

Harley (page 35)

Harley's our little cuddle dog. She is the smallest of our three shelter dogs and has the biggest personality. She can always make us smile and lights up our day.

Deanna and Nathan Kitzke

Bagel *(page 47)*

Bagel is now only eight months old and has graduated from beginner dog classes. He is very affectionate and loves to come up and give hugs. I am impressed that the humane society was able to take care of him with so many animals, and that Bagel was able to come out of it with his own personality and style. My husband and I cherish every day with Bagel.

Brandon and Wendy Koca

Annie *(page 55)*

I knew Annie was to come home with me the moment we laid eyes on each other in the puppy pen at the humane society. She was an eight-week-old, 2½-pound ball of shaggy, pure white spunk and joy. Our eyes met, she jumped on my hand, and I filled out the adoption papers. I have been grateful and glad for her every day since then.

Today she is a 12-pound ball of pure white dreadlocks, love, and energy. Everything she does is done with the enthusiasm that only a happy creature can feel.

Annie is well behaved and sensitive to my moods—a happy, fulfilled little girl who lives every moment with joy. I am so happy that we found each other. We will be lifelong friends.

Judith Steen

Photographing puppies

Humane societies, animal shelters, SPCAs, and dog rescue centers rely on the kindness of animal lovers to care for their puppies and adult dogs, so there is no shortage of ways to become involved with your local rescue center. Volunteering is a fantastic way to spend time with the puppies even if you can't foster or adopt. If you are unable to volunteer and still wish to help, donations are always appreciated. Please contact your local rescue center to learn about its specific needs.

Shelters often welcome help in photographing puppies for their adoption profiles. Here are a few of my tips and tricks to get you started.

- First and foremost is the safety of the puppy. Find a work area that is secure so the puppy cannot escape.

- It is often a good idea to work with an assistant, who can help keep the puppy in position and be another set of eyes to make sure the dog stays out of trouble.

- Some puppies are nervous when you take them away from their littermates. It can be helpful to work with more than one puppy at a time. This is also a great way to get some group portraits or photographs of the puppies playing with one another.

- Work with lots of light. I use studio strobes, but they are not essential. Turn on all of the lights in a room or work in front of a large window. The more light you have, the faster you can set your shutter speed, which allows you to avoid motion blur.

- Raise the ISO rating on your camera if necessary. You will achieve the best-quality photograph using the lowest ISO rating possible, but when it comes to the choice of avoiding "noise" with a low ISO rating or capturing a streak of fur with a relatively long exposure, you should opt to increase your shutter speed by increasing your ISO setting.

- If you find that your camera's focus and shutter release are too slow, try using your continuous mode setting. Using this method will result in a relatively low percentage of top-quality photographs, but if you fire off ten shots and have only one or two good photos to show for it, you still come away with a couple of usable images for adoption pages.

- Work with a variety of toys and treats at your disposal. It's always best to start without distractions because some puppies, once they know there is food or a fun toy to be had, will become overexcited, making it more difficult to create a good portrait. Add enticements as necessary. It's important to have a variety, because not all puppies like the same things. As a general rule, the younger the puppy, the more difficult it will be to find a good enticement because they don't know about toys and haven't yet developed the taste for treats.

- If you come to realize that a puppy is terribly frightened by the experience, stop trying to photograph him, and instead have a little play or snuggle session. Puppies can be highly impressionable, and you don't want inadvertently to instill a lifelong fear just for the sake of some adoption photos.

- Eliminate the background clutter from the photo, so that the portrait features only your subject. Ensure the emphasis is on your model by either using a backdrop or photographing with a shallow depth of field.

- I find it easier to work with the puppy on a table, so that I can readily put my camera at the same level as his face. If you try this, be very aware of the position of all of the table edges, and ensure the puppy's safety by keeping him from falling or jumping off the table.

- Lastly, have fun! If you keep your session upbeat, you and your puppy models will have a good time.

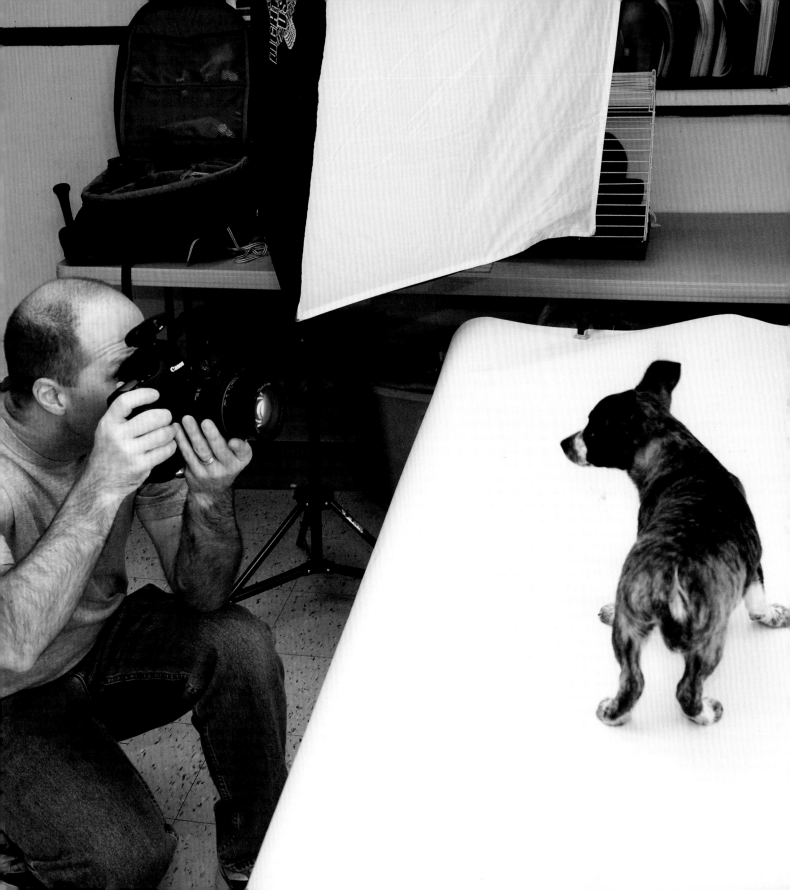

Facts and figures

- An estimated three to four million cats and dogs are euthanized every year in the United States.

- There are almost 78 million dogs in U.S. households, and 39 percent of homes have at least one dog.

- According to a study by the National Council on Pet Population Study and Policy (NCPPSP), 6.04 million puppies are born every year, and 43 percent of those are from unplanned pregnancies.

- About 30 percent of lost dogs (both puppies and adults) brought to U.S. shelters are reclaimed by their owners.

- In 2009–2010, some 19 percent of owned dogs in the United States were adopted from animal shelters.

- Although the number of dogs being brought to U.S. shelters is on the rise, adoption rates are increasing and euthanasia rates are declining.

- 75 percent of owned dogs are spayed or neutered.

- Approximately $2 billion of U.S. taxpayers' money is spent each year capturing, caring for, euthanizing, and disposing of homeless animals.

Sources: The Humane Society of the United States; Veterinarynews.dvm360.com; Journal of the American Veterinary Medical Association; Change.org

Charitable organizations

The puppies featured in this book were all photographed while they were waiting for their "forever homes" and, in most cases, were photographed at the animal shelter or humane society providing their care. For more information about these facilities, visit their websites:

Benton-Franklin Humane Society
bfhs.com

Tri Cities Animal Shelter
tri-citiesanimalshelter.com

Woodford Humane Society
woodfordhumanesociety.org

UNITED STATES

The American Society for the Prevention of Cruelty to Animals (ASPCA)
aspca.org

Founded in 1866, the ASPCA was established with the goal of creating legal protection for animals. Today, it provides local and national leadership on animal welfare issues, with the support of more than one million people across the United States.

The Humane Society of the United States (HSUS)
humanesociety.org

Established in 1954, the HSUS is the nation's largest animal protection agency. It seeks to better the lives of all animals through legislation, education, investigation, advocacy, and fieldwork.

American Humane Association (AHA)
americanhumane.org

Founded in 1877, the AHA works to protect both animals and children, with the aim of affecting legislative policy and educating the public and other animal rights groups.

Best Friends Animal Society
bestfriends.org

Established in 1991, Best Friends Animal Society promotes the philosophy that "kindness to animals builds a better world for all of us." It runs the nation's largest animal sanctuary, and campaigns to end the killing of homeless animals in shelters.

PetSmart Charities
petsmartcharities.org

Founded in 1994, PetSmart Charities operates Adoption Centers in all PetSmart stores across the United States and Canada, where local animal welfare agencies can find new homes for adoptable animals. PetSmart Charities has donated over $100 million to animal programs in North America while helping to save more than four million pets.

AUSTRALIA

RSPCA Australia
rspca.org.au

Established in 1980, the RSPCA is the leading authority in animal care and protection in Australia. Its shelters across the country receive more than 144,000 animals every year.

CANADA

Canadian Federation of Humane Societies (CFHS)
cfhs.ca

Established in 1957, CFHS serves as the national voice of animal welfare organizations across Canada. It promotes the humane treatment of all animals, and champions legislation that improves animal protection and aims to end cruelty.

Canadian Society for the Prevention of Cruelty to Animals (CSPCA)
spcamontreal.com

Established in 1869, the CSPCA is the oldest humane society in Canada. The Society's mission is to protect animals against negligence, abuse, and exploitation. It rehomes over 15,000 animals each year.

UNITED KINGDOM

The Royal Society for the Prevention of Cruelty to Animals (RSPCA)
rspca.org.uk

The RSPCA was the world's first animal welfare charity, founded in 1824. It works to prevent cruelty, promote kindness to, and alleviate the suffering of all animals. Its centers and branches across England and Wales find new homes for over 70,000 animals each year.

Dogs Trust
dogstrust.org.uk

Founded in 1891 as the National Canine Defence League, Dogs Trust is now the largest canine welfare charity in the United Kingdom, caring for around 16,000 dogs each year. Its goal is to ensure that all dogs can enjoy a happy life, free from the threat of unnecessary euthanasia.

Battersea Dogs & Cats Home
battersea.org.uk

Established in 1860, Battersea, in south London, is the UK's oldest and most famous animal rescue center. Every year the home takes in around 10,000 dogs and cats, and it prides itself on never turning away a dog or cat in need of help.